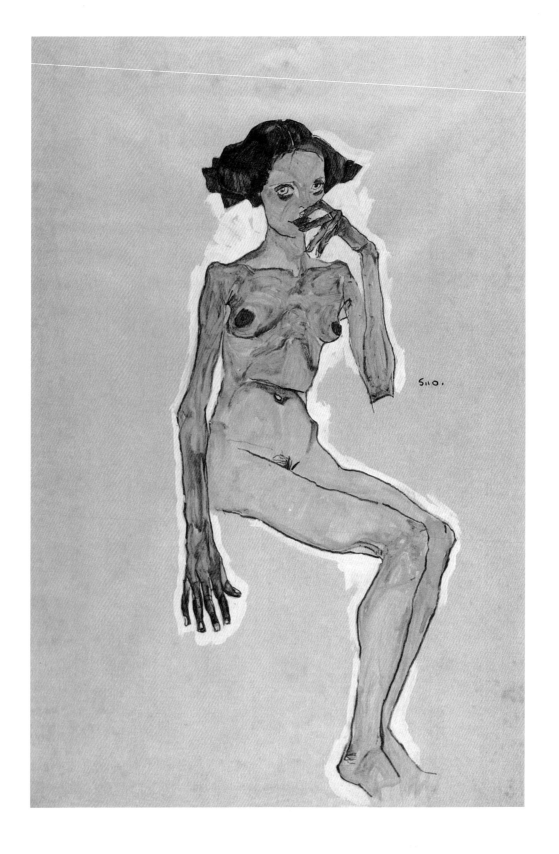

Reinhard Steiner

EGON SCHIELE

1890–1918

The Midnight Soul of the Artist

TASCHEN

KÖLN LONDON MADRID NEW YORK PARIS TOKYO

© 2000 Benedikt Taschen Verlag GmbH
Hohenzollernring 53, D–50672 Köln
www.taschen.com
English translation: Michael Hulse, Cologne
Cover design: Catinka Keul, Angelika Taschen, Cologne

Printed in Germany
ISBN 3–8228–6327–0

Contents

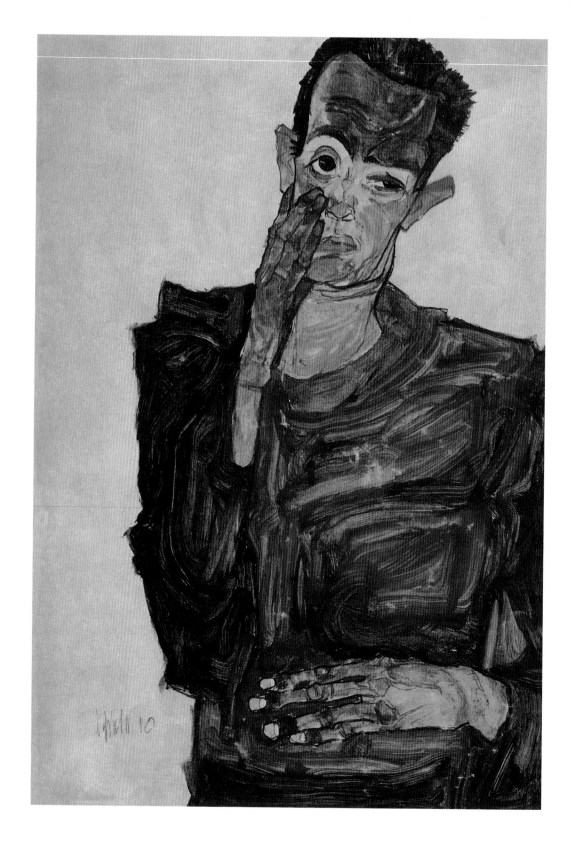

The Artist's Self

Just as there are particular words or phrases (such as *décadence* or *fin de siècle*) which seem to express the very essence of an entire era, of a certain society's wishes and desires, aims and preoccupations and guiding principles, so too there are key images in every artist's work that reveal his character and the wellspring of his creative impulses most clearly of all. There may of course be reasons, of a conscious or unconscious nature, why an artist returns time and again to a specific motif, why it preoccupies his imagination, why it strikes a dominant note in his oeuvre. But we shall at any rate be entitled to see in it a focal meaning underpinning much that is expressed elsewhere in the artist's work. We are especially entitled to make this assumption when (as in the case of Egon Schiele) the motif so insistently foregrounded is the self-portrait. The huge number of about a hundred self-portraits not only shows that of all artists Schiele was one of those who observed himself most closely. It also suggests a trait in the artist that we might consider narcissistic. It is true that Schiele certainly did devote a manic scrutiny to his own person, and liked to record his own appearance and poses. But this preoccupation has a long and respected tradition in art, and we are right to hesitate before hastening to judge. A brief look at the self-portrait tradition is advisable if we are not to jump to dilettantish conclusions.

Egon Schiele in his studio, 1915

One essential component in the process of portraying the self is the mirror. Albrecht Dürer and Rembrandt, to name just two of the most important painters of self-portraits, used the mirror in order to record their own appearance and so establish an autobiographical account. In Dürer's case, indeed, the artist availed himself of an aspect of the mirror which marked the beginning of a central development in the art of the modern era: the mirror was an instrument in the discovery of personal identity, making the self experientially accessible and in the process highlighting the burgeoning personal self-confidence of Renaissance visual artists. At the age of thirteen, in 1484, Dürer was already drawing a self-portrait to which he was later to add the words "likeness done from a mirror". In 1492 he recorded a passing state of melancholy in a pen and ink drawing. In further self-portraits done in 1493 and 1498 a young and well-dressed man, of confident address, aware of his station, could be seen presenting himself for inspection. At length, around 1500, Dürer painted a self-portrait in which the hieratic frontal view and the compositional similarity to images of Christ strike the modern eye as verging on blas-

Self-Portrait Pulling Cheek, 1910
Selbstbildnis mit Hand an der Wange
Gouache, watercolour and charcoal,
44.3 x 30.5 cm
Vienna, Graphische Sammlung Albertina

7

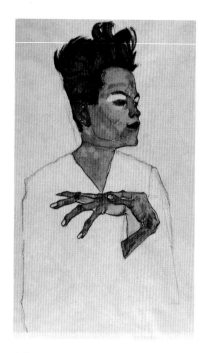

Self-Portrait with Hands at Chest, 1910
Selbstbildnis mit Händen vor der Brust
Gouache, watercolour and charcoal, 44.8 x 31 cm
Private collection

phemy. But one feature above all indicates that Dürer was in fact engaged in securing his own personal identity, his awareness of his individual self: his body, far from being allegorized or cosmetically idealized, is shown as it is, and the subject appears stripped bare or indeed as a sexual creature. In a word, whatever the poses or facial expressions adopted in self-portraits by Dürer (or, similarly, Rembrandt, Ferdinand Hodler or van Gogh), he still remains identifiably Dürer, because his cardinal belief is in the identity of the individual. Probing, experimental portraiture which explores the self through the roles of others (Christ, a clown, a hero, a victim) does not in so doing abandon the principle that the 'individual' is by definition and etymology one 'in-divisible' self. Even when the role-playing borders upon radical defamiliarization, the self is never so utterly breached as to be split.

Schiele, in terms of the figural and figurative options available to the self-portrait, comes at a final point in a process of evolution, a point at which the self is in fact experienced as divisible – as a dividual, so to speak. With the exception of early works dating from 1905 to 1907, Schiele's self-portraits no longer fit very well into either the category of autobiographical reportage or that of hero-worship of the self. The poses he strikes in them are extraordinary, his gestures highly affective, and the portraits deny and dismantle the oneness of the self. A tension is created between the actual self and the self seen in alienated form in the picture, and this tension attests not the confirmed certainty of individual identity but rather its end. Some of the self-portraits may recall Oscar Wilde's *The Picture of Dorian Gray* (1890), in which the painted self grows older while the beauty of the real self remains unchanged. The novel makes so powerful an impact because it reverses the normal relation of sitter to painted image: the image becomes the true mirror of the soul, revealing traits the living original does not. Plainly Schiele's contemporaries occasionally felt something of the kind when they considered his self-portraits. Friedrich Stern, for instance, wrote in a review dated 11 November 1912: "And he has a self-portrait which is difficult to make out for the simple reason that the rot he feels he must show his youthful face in the grip of has advanced too far. It's all very sad. . ."[1] So the image in his mirror served Schiele not as a way of fixing his identity but to promote the quest for the other self he portrayed in his pictures.

If at this point we attempted to review the significance of mirrors in the development of children and in narcissism (Jacques Lacan has even coined the term "mirror phase"), it would be a necessarily abridged account. Instead, let us take a look at mirror images in relation to the visual arts – a context in which the mythical figure of Narcissus appears as the prototypical hero of the art of painting. In Leon Battista Alberti's *Trattato della Pittura* (1435/36), one of the basic texts in modern art theory, painting is lauded as an art of veritably divine power. Alberti claims that in copying or imitating things, painting makes them nobler, more valuable. For Alberti, painting is the doyen of all the arts, and whatever beauty exists has its origin in painting. He continues: "Thus, with a statement the poets made in mind, I would tell my friends that Narcissus, who was transformed into a flower, was the true inventor of painting.

For, just as painting is the flowering glory of all art, so too the tale of Narcissus applies in another sense. For can you well say that painting is anything other than seeking by artistic means for a likeness, like that likeness which gazed back from the mirror surface of the pool?"[2]

Since Alberti's time the principles of art have of course undergone radical change, particularly in respect of mimesis. And yet it remains a remarkable fact (and one that is applicable to other modern phenomena) that Alberti should have identified the mirror image as the prototype of painting, and so opened up the option of seeing art as the artist's self-portrait. This made it possible to transfer the importance and power of the mirror (as a means of experiencing the self) to the visual arts – a transfer which was indeed made. As well as Wilde's *Dorian Gray* we might well think of André Gide's *Traité du Narcisse* (1891), a symbolist work that carries even greater conviction. In it, Gide took the myth of Narcissus as an analogy for the life of the poet. Ernst Robert Curtius interpreted this as an image of archetypal modern man "bending over the mirror of art to recognise himself there" – modern man, who knows "that he perceives no more than the reflection of things . . . and forever remains an onlooker." The attitude is thoroughly consistent with the views of the decadent literary *fin de siècle* which, as Hugo von Hofmannsthal attested, experienced duality as the human condition and merely observed life. This only partly applies to Egon Schiele and his self-portraits, though.

What first strikes us in the earliest self-portraits (1905 to 1907) is Schiele's attempt to use grandiose, exhibitionist versions of himself to compensate for the absence of his dearly-loved father's praise (the father had recently died). One gloss reading "mirror self-portrait 06" provides a significant pointer. Doubtless it was good for the young Egon's artistic self-esteem when he was accepted into the Vienna Academy at the early age of sixteen. The self-confidence is all there, in his dandified pose with palette in hand. After his "Klimt period" – that is to say, from 1910 on – greater tension enters Schiele's self-portraits. From then till 1913 the expressive repertoire is used to excess, so that it is not always easy to see the pictures as self-portraits. They contest the defined clarity of a single individual who, for all the variety in his appearance, remains one and the same. The mirror is a distorting one now, the mirror image an alter ego, an alien self. In this period of continual attempts to escape from the confines of a defined personality, the major characteristics are ascetic physical slimness, contortions, grim and bizarre facial expressions governed by no readily understandable affects, and often a shock of hair that seems to be standing on end as if electrified (cf. p. 11). The defamiliarization that is already in the pose struck in front of the mirror is matched in the drawings and paintings by a form which (viewed in terms of mimetic realism) parts company with the original subject. Yet this does not produce archaic authenticity, but rather a modern sense of the torn self. It is a theatre of the self which is in dangerous proximity to Friedrich Nietzsche's aphoristic description (in 1888) of the modern artist: "The modern artist, physiologically close kin to the hysteric, bears the signs of hysteria in his very character too . . . The absurd excitability

Self-Portrait with Bare Stomach, 1911
Selbstbildnis mit entblößtem Bauch
Watercolour and pencil, 55.2 x 36.4 cm
Vienna, Graphische Sammlung Albertina

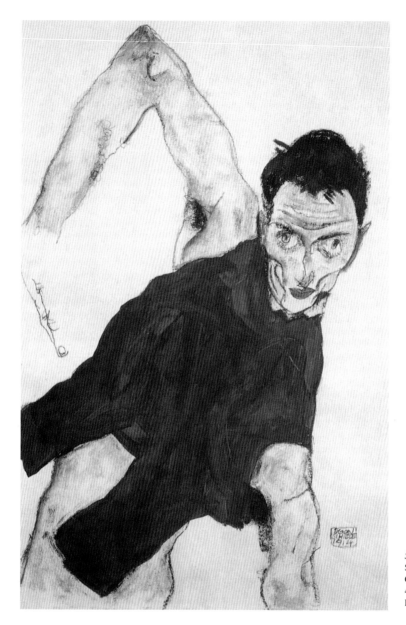

Self-Portrait with Raised Right Elbow, 1914
Selbstbildnis mit erhobenem rechten Ellbogen
Gouache, watercolour and black chalk,
47.6 x 31.1 cm
Private collection

of his constitution, which makes a crisis of every experience and drags drama into the merest chances of life, renders him utterly unpredictable: he is no longer one person, but at most a gathering of persons, and now this one, now that will be most conspicuous amongst them, with unabashed confidence. That is precisely why he is a great actor: all these poor creatures lacking in will, these subjects for close medical scrutiny, are astounding for their mimic gifts, their powers of transfiguration, their ability to enter into any required character."[3]

Schiele will undoubtedly have encountered Nietzsche's ideas and writ-

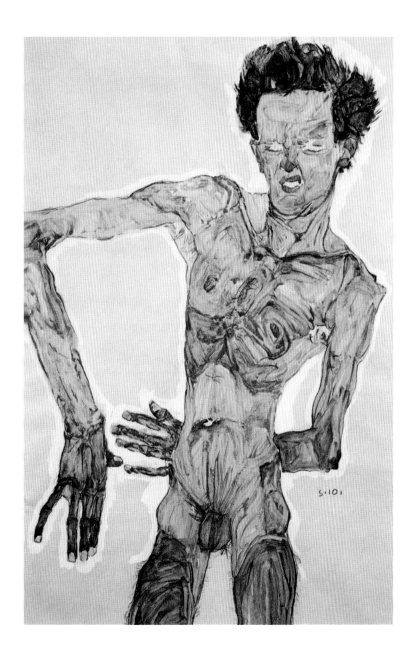

Self-Portrait Standing, 1910
Aktselbstbildnis
Gouache, watercolour and pencil
with white highlighting, 55.8 x 36.9 cm
Vienna, Graphische Sammlung Albertina

ings, which were as current in Vienna as they were in Munich and Berlin. But we cannot assume that Schiele, a man who was ruled by the eye and by sensation, read or even studied Nietzsche himself; and indeed it hardly matters. The fact remains that many of his pictures and poems are cognate with Nietzsche, beyond any question of direct influence – for instance, with Nietzsche's idea expressed in *Thus Spake Zarathustra*: "Behind your thoughts and feelings, my brother, stands a mighty master, an unknown sage. His name is Self. In your body he dwells. He is your body."[4] In Schiele, the naked body was becoming a central subject in the

11

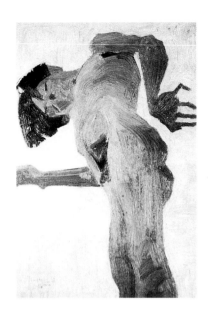

Nude Study, 1908
Aktstudie
Oil on cardboard, 24.4 x 18 cm
Private collection

portrayal of self from 1910 onwards (p. 13). In his nude self-portraits, Schiele adopts a programmatic opposition to the ornamental concealment of the body practised by Gustav Klimt (p. 22) and the Secessionists. For Schiele, the nude is the most radical form of self-expression not because the body is exposed but because the self is grasped entire.

This exhibition and isolation of his own bodily self is accompanied by a stern refusal to indicate spatial circumstances. Schiele neutralizes the "background" by using a monochrome one-dimensionality that makes the bodies look insecure and gives their movements a spasmodic or nervous quality. The irregular, angular outlines of the figures, contrasting so sharply with the neutral backgrounds, contribute to the defamiliarization of a natural mirror image and make possible a greater physical expressiveness. This distinguishes Schiele's nudes from the unusual and often provocative pictures of Richard Gerstl (1883–1908), who must be considered Schiele's only Viennese precursor in the nude self-portrait.

Particularly when Schiele crops or, as it were, mutilates the body to a mere torso (p. 9) we see how little his scrutiny and self-portrayal has to do with external, superficial appearances. His use of colour does not serve as an account of the body's natural characteristics. Rather, the arresting highlights and the broad, brusquely juxtaposed brush-strokes indicate vital energy. Together with the occasional use of a thick white outline around the figure, this use of paint puts us in mind of a letter Schiele wrote, in his distinctively clumsy and somewhat unclear style, to Oskar Reichel in September 1911: "When I see myself entire, I shall have to see myself and know what I want, not only know what is happening within me but also to what extent I have the ability to look, what means are mine, what enigmatic substances I am made of and of how much of that greater part that I perceive and have hitherto perceived in myself. – I see myself evaporating and exhaling more and more, the oscillations of my astral light are growing faster, directer, simpler, and like a great insight into the world. Thus I am constantly accomplishing more, producing further and infinitely more shining things from within myself, insofar as love, which is everything, endows me in this way and leads me to what I am instinctively attracted by, what I want to drag into myself, in order to make something new anew that I have seen in spite of myself."[5]

If we look at some of Schiele's post-1910 self-portraits with this passage in mind, we may well suspect that he considered them the concrete artistic realisation of spiritual substance. The white outline would be an aura, in that case, corresponding to the "astral light" and related to the ideas of Rudolf Steiner or one of the other popular theosophist schools. It seems that Schiele espoused these ideas and integrated them into his own world view as uncritically as he did the thinking of Nietzsche. Only thus can we account for the messianic tone in which Schiele sometimes writes of his own artistic charisma: "My being (*Wesen*), my decadent non-being (*Verwesen* - Schiele's pun is inscrutable and untranslatable – translator's note), transposed into enduring values, must sooner or later exert great power over highly or more highly educated beings, like a religion with all the appearance of plausibility. – Far and wide people will pay attention to me, those who are even more remote will look at me,

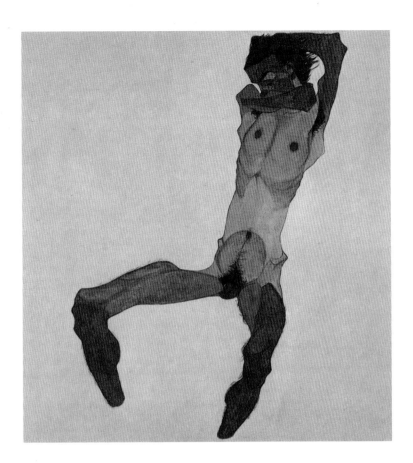

Seated Nude Male, 1910
Sitzender männlicher Akt
Oil and gouache, 152.5 x 150 cm
Private collection

and my negatives will live from my hypnosis! – I am so rich that I must give myself away."[6]

Of course it would be wrong if our consideration of the nude self-portraits did not examine the narcissism and exhibitionism involved. The artist, naked, is after all exhibiting himself as a sexual creature (p. 15). It may well be true that Schiele was out to exorcise sexual devils, and was living out in his imagination "impulses that could not always be satisfied in reality"[7]. In other words, to portray one's drives and passions is to cope with them. However, this does not seem fully adequate as an explanation, at least in the case of the nude self-portraits. Schiele's friends did not exactly describe him as an unbridled erotomaniac; and, given the frequently unsightly, tortured look of his nakedness, it would be a mistake to overstress the erotic component. What seems of greater moment (and is expressed in his letters and poems) is the fact that Schiele placed great emphasis on understanding and exploring the self. This exploration was not a mystical, anti-physical thing for him; rather, it was a way of locating energies released through the medium of the body as spiritual substance.

To explore the self is always to render the self a duality, though, since the subject conducting the exploration is also its object. Max Klinger ex-

pressed this occidental thought in his *Vom Tode. II. Teil* in the image of the naked philosopher who can attain knowledge of the world only via the knowledge of himself conferred by his mirror image. Henri de Toulouse-Lautrec approached the theme quite differently in *Monsieur Toulouse paints Monsieur Lautrec-Monfa* (1890), which uses a dual image to indicate the split between the painter and the aristocrat sitting for him. The phenomenon of split personality, successfully given ironical treatment by Toulouse-Lautrec, had been made into a classic horror tale four years earlier in Robert Louis Stevenson's *The Strange Case of Dr. Jekyll and Mr. Hyde* (1886), which used the ancient motif of the doppelgänger alongside Faustian experimentation of an epistemological nature.

Schiele too dealt with the phenomenon in a number of works. The most important is his 1910 painting *The Self-seers.* (There is a second version, painted in 1911, which is also known as *Death and Man.*) The *Self-seers* title is initially bewildering because it does not readily seem to identify the content of the picture. The figures in the painting, both vaguely identifiable as Schiele himself, are not looking at each other but rather frontally at us as we look at the picture: that is to say, if we presuppose the presence of a mirror image, the painter is looking at himself, and the title thus concerns Schiele's relation with his own painting – the painting redoubles the mirror image of his own self. The figure to the fore is almost completely naked; the dark cloth that falls across shoulder and arm to the legs is not a demarcation between this figure and the other but rather a layer of protective covering. To the fore it cloaks a thin, delicate figure, while the second man, his facial expression and gestures somewhat different, is nestling up to the first, a shadowy and almost insubstantial figure gazing out of the picture across the first man's shoulder. In this work we may detect the idea (which Schiele possibly drew from esoteric sources) that everybody has a doppelgänger who may appear as a spiritual aura; but in the 1911 version, *Death and Man*, the motif of the doppelgänger as a premonition of death (common in turn-of-the-century literature) is specifically present. Here, the pale and shadowy alter ego is a threatening harbinger of death, and the treatment has a visionary eeriness that goes far beyond other contemporary paintings on the subject of the painter and death, such as that by Lovis Corinth (1917)[8].

We can now begin to grasp why the self-portrait is so crucial in Egon Schiele's oeuvre. Every essential facet of human life can be expressed in a self-portrait – and death. It is a concave mirror in which experience of the world and the self is concentrated in one image. Viewed like this, the self-portrait in Schiele is a palpable realisation of what Paul Hatvani wrote in his 1917 "Essay on Expressionism": "The Expressionist work of art is not only connected but indeed identical with the artists' awareness. The artist creates his world in his own image. The ego has attained mastery in divinatory manner."[9] Hatvani's observation points the way to a re-interpretation of the myth of Narcissus, one that applies not only to the self-portraits but to Schiele's entire work. The modern Narcissus does not create an artistic image that reproduces the real shape of things; rather, he reverses the perspective scrutiny of the world, and in this rever-

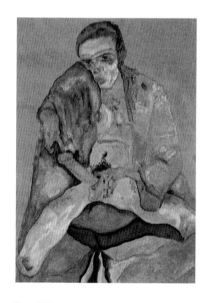

Eros, 1911
Gouache, watercolour and black chalk,
55.9 x 45.7 cm
Private collection

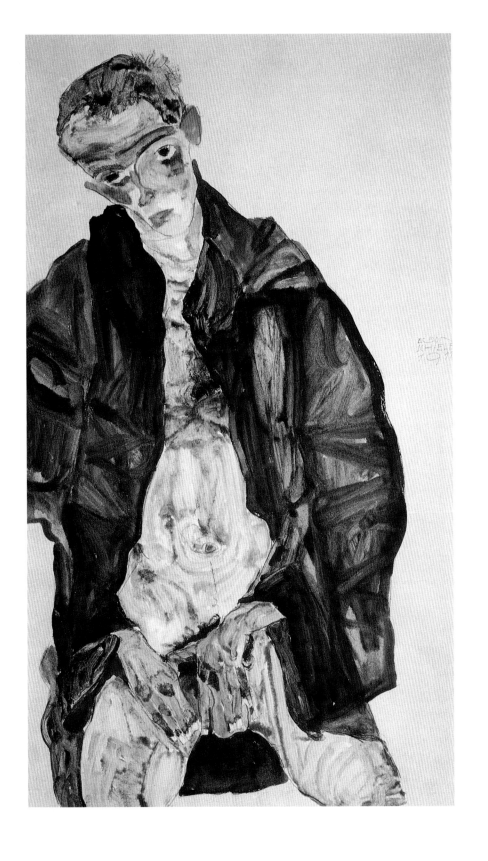

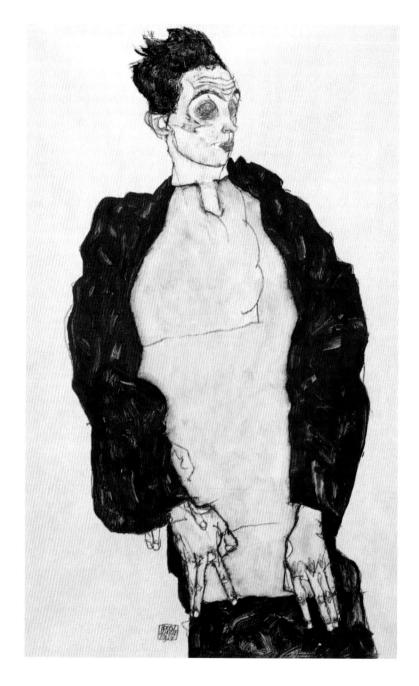

Self-Portrait in Lilac Shirt, 1914
Selbstbildnis in lila Hemd
Gouache, watercolour and pencil, 48.4 x 32.2 cm
Vienna, Graphische Sammlung Albertina

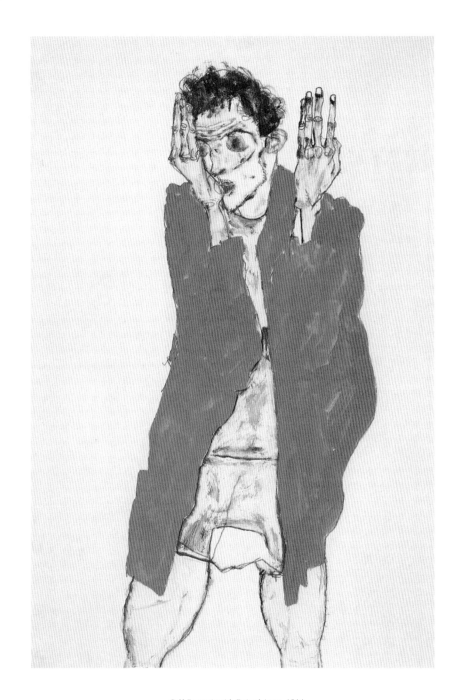

Self-Portrait with Raised Arms, 1914
Selbstbildnis mit erhobenen Armen
Gouache and pencil, 48.4 x 32.1 cm
Private collection

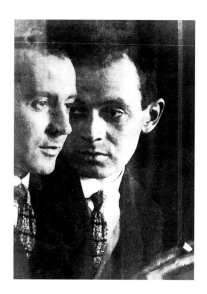

Egon Schiele, c. 1915
(double exposure)

The Prophet (Double Self-Portrait), 1911
Der Prophet (Doppelselbstbildnis)
Oil on canvas, 110.3 x 50.3 cm
Stuttgart, Staatsgalerie

sal the ego or subject itself becomes the horizon, as Nietzsche put it. Every object that might be the subject of a drawing or painting becomes a self-object – that is, an object experienced as a part of the artist's own self. To quote Hatvani again: "In Impressionism, the world and the ego, the inner and the outer, had been united in harmony. In Expressionism, the ego inundates the world. Thus there is no longer an outer realm: the Expressionist makes art real in a way hitherto unanticipated . . . After this tremendous act of inwardness, there are no longer any preconditions for art. And so it has become primary and elemental."[10]

Hatvani (who incidentally wrote an obituary of Schiele[11]) saw Expressionism as a response to Impressionism, in which the world and the ego had admittedly been in harmony but where the ego had become an illusion that was no more than the sum of disparate sensations. According to the physicist Ernst Mach, who spoke of the "irredeemable self" in his *Analysis of Sensation* (1886), the world and the ego disintegrate into a vast number of disparate constituents and sensations. No one put this better than Hugo von Hofmannsthal in his fictional letter from Lord Chandos to Francis Bacon (1902): "Everything fell apart, and those parts fell apart again, and nothing could be encompassed in a concept any more. Individual words floated about me; they ran together and formed eyes that were staring at me and which I was compelled to stare back into: they are whirlpools and I feel giddy at the thought of looking down into them, they turn ceaselessly, and through them one passes into emptiness."[12] Schiele countered the sensory fragmentation of the self by means of a multiple self which came little by little to form a visual concept which reconstituted his unity with the world in a visionary way. Photographs taken in 1914 and 1915 show that the man of conflict constantly threatened with fracture had changed decisively (p. 18). True, Schiele was still interested in the doppelgänger or alter ego; but photography prevented total depersonalization. His new self-confidence, which was reinforced by private circumstances, meant that in the work of Egon Schiele's last years of life there were but few self-portraits, and in those the unity of self and self was almost seamlessly restored.

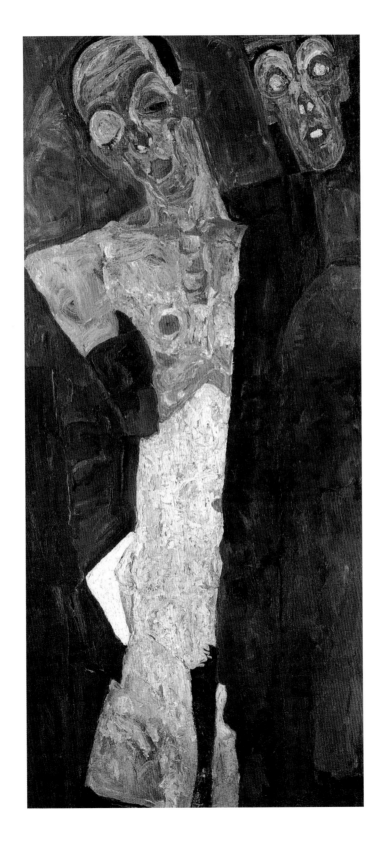

"I went by way of Klimt"

Egon Schiele was born on 12 June 1890 at Tulln in Lower Austria. His mother Marie (née Soukup) came from Krumau in Bohemia. She had given birth to a girl in 1880 and a boy in 1881, both still-born, and Elvira, born in 1883, lived to be only ten. Melanie was born in 1886, and after Egon came his favourite sister Gertrud in 1893. Egon seems to have been particularly close to his father, Adolf Eugen Schiele. Schiele senior came from northern Germany and was stationmaster at Tulln, and it was from him that Egon inherited his lifelong penchant for railways. His grandfather had been a railway engineer too; so was his subsequent guardian, Leopold Czihaczek; and in due course Egon's sister Melanie also worked on the railways. His first childhood drawings were of trains, and if we consider his landscapes and townscapes with their uninterrupted string of linked visual units (p. 91) we often have the feeling that they record the view from a train window. Whenever he could not stand "cold Vienna" he would not infrequently take a train to Bregenz and then promptly take the next train back to Vienna. When he was invited to visit his mentor, the art critic Arthur Roessler, at Altmünster by Lake Traun in July 1913, Schiele pedantically wrote listing all his possible arrival times, only to travel at a quite different time from a quite different direction. At Roessler's holiday home, as the critic later recalled in his memoir, Roessler was one day confronted with "an astonishing sight: there in the middle of the room sat Schiele, on the bare floor, with a very pretty clockwork toy train racing around him in circles . . . Much as I was taken aback by the sight of this young man earnestly occupied with a child's toy, I was still more taken aback by his uncanny virtuosity with which he produced the many and varied sounds of hissing steam, the railwayman's whistle, wheels in motion, rail joints, creaking axles and squeaking suspension, bursts of steam when a train was starting and the squeal of steel when it was braking . . . Schiele's performance was astounding. He could have gone on a varieté stage any time."[13] And yet in fact he couldn't have, because for all this display of virtuosity Schiele was no showman. His high spirits expressed a "childlike nature"[14], and he was a reserved person who preferred his own company to that of others.

Egon Schiele was a weakly and silent child. He did not shine at the grammar schools in Krems (1902) or Klosterneuburg (1902–06), and even had to repeat one year, for which indignity he later avenged himself

Gustav Klimt
Reclining Semi-nude Girl, 1904
Liegender Halbakt
Pencil with white highlighting, 37.2 x 56.5 cm
Berne, E. W. Kornfeld collection

Reclining Girl, 1910
Mädchenakt, halb liegend
Pencil, 55.7 x 37 cm
Graz, Neue Galerie am Landesmuseum
Joanneum

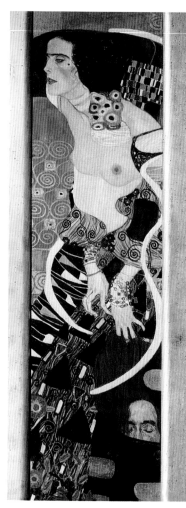

Gustav Klimt
Judith II, 1909 (Detail)
Oil on canvas, 178 x 46 cm
Venice, Galleria d'Arte Moderna

by ungraciously commenting that his "uncouth teachers" were always his "enemies". The only subject for which he could muster any enthusiasm was drawing: his Klosterneuburg teacher Ludwig Karl Strauch, the painter Max Kahrer, and Wolfgang Pauker, master of the Augustinian choir, all supported his early efforts. And it was they who approved his application to the Academy in 1906, in the face of guardian Leopold Czihaczek's objections.

The year before that move was one of the most painful in Schiele's life. On 1 January 1905 his father had died of an advancing (possibly syphilitic) paralysis, his mind gone. Quite apart from the financial difficulties that resulted, Schiele was now without the most important person in his life. He never had a particularly intimate or even warm-hearted relation with his mother; in letters to her he could at times be condescending or even superior when she criticized him for being spendthrift. But his father's loss made a lasting impression, and years later his father still spoke to him in dreams. Death was certainly no stranger to the Schiele family; and we have Schiele's own word for it that death shaped him as an artist. Death became a major Schiele theme. In the short term, though, his father's death meant that young Egon was the only "man" in the household, and he tried to compensate for the loss by increasing his self-esteem.

After his father's death, self-portraiture (a medium in which maker and sitter are one) was presumably an ideal way for Schiele to make up for the loss of someone who was so important to him and whose approval he now felt the lack of. To put it differently: drawing or painting himself was a perfect albeit narcissistic method of replacing the lost, idealized father imago (Lacan's term).

The very first self-portrait eloquently attests this "narcissism". It is a crayon half-length signed "mirror self-portrait 06" at the top. The signature perpetuates Schiele's near-manic boyhood insistence on "identifying everything that belonged to him, rulers, books or whatever, and also everything he painted or drew, with his painstaking signature and the year . . . Often his pictures bear the signature and date scratched in several times over."[15] What is striking about this self-portrait and another done the same year that shows him in profile with a palette is the fact that he is wearing a suit and wing collar, a naively earnest sign that he was laying visible claim to adulthood. The self-portraits that followed in 1906 and 1907 (that is to say, dating from his Vienna Academy days) also show a fairly self-confident, observant youngster proudly posing with the tokens of the one calling he could even consider following, and being photographed too (p. 94).

His alert gaze in that photo, and the almost dandyish bearing apparent in two 1917 self-portraits, document the role-playing of a young man who sees himself as an artist and wants others to see him the same way. Schiele developed a taste for stylish clothes, a taste he could only satisfy by adopting an imaginative kind of camouflage. To Roessler, Schiele said: "When I began my independent life as a freelance artist, against the wishes of my mother and guardian, I was soon in a terrible state. I was wearing my guardian's cast-off clothes, shoes and hats, all of them too

big for me. The lining of the suit was torn, the material worn, and it was loose and baggy on my skinny frame. The shoes were down at heel, the uppers and soles holed – they were huge ragged things in which I was forced to drag my feet. To keep the pale felt hat with its worn nap and greasy spots from flopping over my eyes I had had to stuff it with folded newspaper. One particularly 'delicate' item in my 'wardrobe' at that time was my underwear. I do not know if those linen rags like fantastic nets could still be termed underwear at all. My shirt collars were heirlooms from my father, far too big for my thin neck and too high as well. For that reason, on Sundays and for 'special' occasions, I wore collars of 'distinctive' shape that I had cut to shape myself from paper. . ."[16] Josef Hoffmann the architect, co-founder of the Wiener Werkstätte, provided Schiele with the opportunity to design stained glass for the Palais Stoclet in Brussels in 1909, as well as art cards and fashion. However, these projects never got beyond the design stage – which has been preserved in his sketchbooks.[17]

Thus in 1906 Schiele had prevailed over his mother and over his guardian Leopold Czihaczek, who knew a fair amount about music but nothing about art, and his wish to study at the Vienna Academy had come true. He started under Christian Griepenkerl (1839–1916), a painter of historical pictures and portraits, a traditional artist who had been a pupil of Carl Rahl. Hitherto, beside portraits of himself and others, Schiele had mainly painted and drawn landscapes and townscapes (of Klosterneuburg, for instance). His talent was scarcely visible in these works. Now the Academy required time-honoured discipline of him: in the first instance, the study of ancient statuary, of the living model, and of drapes. There were compositional exercises too. Schiele had an aversion to the academic form of these exercises, although they helped perfect the draughtsman's gift he already possessed; the Academy's teachings made next to no mark on his personal style. Even as he was taking Griepenkerl's old-fashioned classes he was far more impressed by the flat-dimensioned linear style of Gustav Klimt (1862–1918) and the Secession artists, and their influence became apparent in some of his work.

Thus Egon Schiele declared his affinity to a movement which, ever since the Secession (an artists' group) was constituted in 1897 and their own exhibition premises, designed by Joseph Maria Olbrich, were built in 1898, had been the most progressive in Austria (even though they hardly merited the term "avant-garde" if compared with other European schools of the time). "May the times have their art, and may art have its freedom": Ludwig Hevesi's slogan served to propel the Secessionist attack on the rigid academic conventions of historicism, and inspired the Secessionist belief that art and life must be harmonized. Their publicity appeared in the periodical *Ver Sacrum*, which described the aims and subjects of art and the tasks facing it. The Wiener Werkstätte, founded in 1903 by Josef Hoffmann, Koloman Moser and industrialist Fritz Waerndorfer, became the sanctum of this "sacred springtime". There, crafts were undergoing a revival, and the goal was to transform the entire human environment into a realm of beauty. But it was Gustav Klimt who

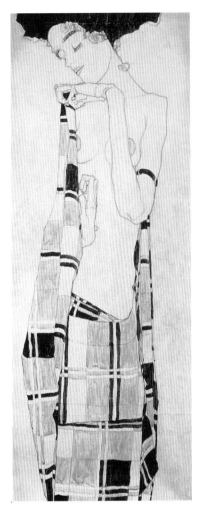

Standing Girl in Checked Cloth, 1910
Stehendes Mädchen in kariertem Tuch
Watercolour and charcoal on cardboard,
134 x 52.7 cm
Minneapolis, The Minneapolis Institute of Arts, Gift of Dr. Otto Kallir and the John R. van Derlip Fund

was seen as the new movement's Messiah by those who hoped that art could heal the ills of mankind and that a decorative veil drawn over hard reality was the next thing to redemption. "There is no doubt," comments the critic Werner Hofmann, "that an artistic endeavour that values the decorative and accords it supremacy over the deeds and sufferings of humanity cannot accommodate discord, the outbursts of pain, or tragedy, but will level them all out in universal harmony. This is what Klimt (with the one exception of *Jurisprudence*) did his whole life long. In *The Kiss* he robbed the man's and woman's bodies of all tension and delegated it to the contrast between right-angled and curved patterns. The gold raining into the lap of *Danae* lends the ancient motif, together with the ornamental treatment of the body, a remotely sacred air; the particular sense of desire created by the intoxicating decorativeness is more than a

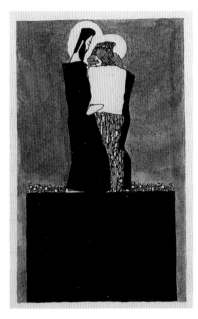

mere embellishment, and accomplishes what a male lover could not, transforming the flesh into an ornamental cipher, a work of art. Eros becomes an icon."[18]

While Schiele was at the Academy, Klimt became his shining example, one he revered till his death. This in itself was an act of rebellion against Griepenkerl and the dogmatic character of academic instruction. In place of naturalistic drawings of the body and perspective drawing, Schiele adopted Klimt's principles, above all the emphasis placed on the painted surface, which is aided by the fine draughtsmanship and the substitution of decorative for spatial values. Schiele's attachment to Klimt is palpable in the 1907 *Water Spirits I* (p. 27). From Klimt's own *Water Serpents II* (p. 26), painted between 1904 and 1907, Schiele has taken the motif of women seen floating in horizontal suspension, and,

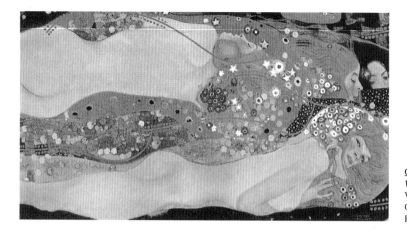

like Klimt, he places them against an ornate surface. But while in Klimt's painting (and generally in his portraits) the sensuous lines of the bodies (painted in a perfectly naturalistic manner) are mantled in abstract decorative shapes and colours, Schiele's figures themselves become a part of the ornamental abstraction of the compositional structure. They are angular bodies, lacking the organic, rounded plasticity of Klimt's figures and looking as if they had been cut out of metal. Related though the motif is, Schiele's treatment lacks the erotic charge of Klimt's; rather, with the introduction of dark male profiles, it has a spiritual tendency. In Klimt's painting, the line still defines the subject, the bodies, even though the figures are aesthetically stylized into melodic, eurhythmic, autonomous forms. But Schiele's line operates independently as an instrument of interpretation: in a sense, it is non-physical, and its very angularity contains affective, expressive qualities.

It is revealing that at almost the same time Wassily Kandinsky was dwelling upon the psychological aspect of the line in his theoretical writings. He assigned the following characteristics to the three main types of angle formed by lines: the right angle (according to Kandinsky) is the most objective, the coldest, and bespeaks self-control; the acute angle is the tensest, warmest, and also sharp and highly active; the obscure angle has a certain clumsiness to it, and is weak, expressing passivity. Kandinsky felt that these three types corresponded to the process of artistic creation: the vision is sharp and active, the actual work is cool and controlled, and once the work is finished comes the sense of weakness.[19]

Although to our knowledge there was no direct link between Schiele and Kandinsky, the latter's observations nonetheless help us understand the nature and character of the most important tool in Schiele's artistic kit: the line, or draughtsmanship in general. Analysis of his work's content apart, we see that angular lines do have a comparable spiritual and psychological charge in Schiele's work. And this implies a radical revision of the Klimt model. In Klimt, figure and ornament relate through the contrast of the naturalistic and the stylized, creating a sophisticated interplay between the revealed and the concealed: flesh becomes an "or-

Water Spirits I, 1907
Wassergeister I
Gouache, coloured chalk, silver and gold paint,
27.5 x 53.5 cm
Private collection

namental cipher". But in Schiele the game is serious. His meanings are conveyed by angular lines that do not conceal but thrust and exhibit. This use of the line still has its decorative side, but instead of being merely stylized ornament it already possesses the qualities of expressive exaggeration and fracture that become dominant after 1910.

Schiele's engagement with Klimt's art was not only a matter of style and motifs. In a postcard design for the Wiener Werkstätte we see Schiele rendering his admiration for Klimt in concrete form for the first time: in an idealized yet perfectly identifiable form he presents the master and himself in a picture where two male figures in monklike garb and with aureoles about their heads are seen on a monumental plinth, the mood devout to the point of being cultic (p. 25). In 1912 Schiele returned to the subject, though with a change in the devotional mood. We see *Hermits* (as the painting is called) and not saints, and the tone is no longer mystical and remote but one of delicate equilibrium between the two men – the elder, Klimt, deathlike, and the younger, Schiele, looking grim, doubtless because the artist leads a solitary life, condemned by society to suffer. Schiele himself wrote in a letter to collector Carl Reininghaus of "the irresolute character of the figures, conceived as bowed and bent, the bodies of men tired of life, suicides, yet still the bodies of people alert to sensation."[20]

At the time that he painted *Hermits* Schiele was already seeing himself as a kind of priest of art, more the visionary than the academician, seeing and revealing things that remain concealed from normal people. He established the foundation for this view of his calling by 1909 at the latest. That year he left the Academy (where, incidentally, he did not do especially well) and founded the short-lived New Art Group (*Neukunstgruppe*) with his friends and former Griepenkerl students Anton Faistauer, Karl Massmann, Anton Peschka, Franz Wiegele, Karl Zakovsek and others. In a manifesto that appeared in slightly revised form in the magazine *Die Aktion* in 1914, Schiele described the artist as one with a vocation and drew up an astounding creed: "The new artist is and must at all costs be himself he must be a creator he must build the foundation

Gustav Klimt
Seated Semi-nude Girl with Closed Eyes, 1913
Sitzender Halbakt mit geschlossenen Augen
Pencil, 57 x 37 cm
Vienna, Historisches Museum der Stadt Wien

himself without reference to the past to tradition. Then he is a new artist."[21] Emphasizing the value of being oneself, of creating from within oneself and for oneself, the nineteen-year-old had hit upon his major theme and concept, which was to determine the course of his personal and artistic evolution (the two are hardly separable anyway).

Though the Second International Art Show in 1909 did not, strictly speaking, fashion Schiele's approach, it did influence his choice of an expressive repertoire. The European avant-garde made an impressive showing at the Show. In addition to Ernst Barlach, Pierre Bonnard, Lovis Corinth, Paul Gauguin, Max Klinger, Max Liebermann, Henri Matisse,

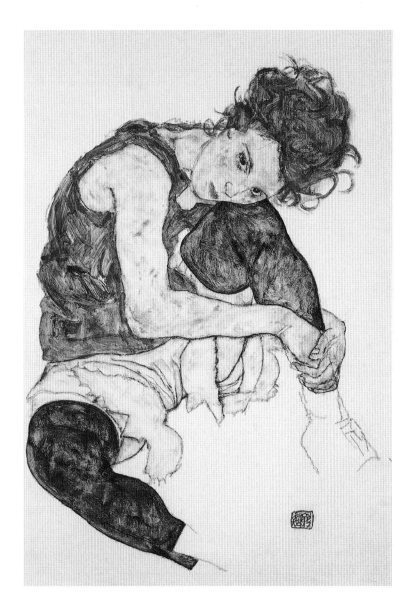

Seated Woman with Left Leg Drawn Up, 1917
Sitzende Frau mit hochgezogenem linken Bein
Gouache and black chalk, 46 x 30.5 cm
Prague, Národní Gallery

Max Slevogt and Félix Vallotton, the Show also included work by Vincent van Gogh, Eduard Munch and the Belgian sculptor Georges Minne – who, with Ferdinand Hodler, was a major influence on Schiele. The Show provided Schiele with his first opportunity to participate in a significant exhibition. Four of his portraits were shown in a room alongside drawings by Oskar Kokoschka, who had already caused a stir at the First International Art Show in 1908 (though in the following year he hardly attracted more attention than Schiele did). Kokoschka seems to have sensed a serious rival in Schiele, four years his junior, and subsequently made some uncharitable remarks about him. Hitherto he had been the

Old Street in Klosterneuburg, 1907
Alte Gasse in Klosterneuburg
Oil on canvas, 96.6 x 53.5 cm
Linz, Oberösterreichisches Landesmuseum

Trieste Harbour, 1907
Segelschiffe in wellenbewegtem Wasser
Oil and pencil on cardboard, 25 x 18 cm
Graz, Neue Galerie am Landesmuseum
Joanneum

sole bogeyman of the bourgeoisie, using any means he could find to get at the middle classes, who had used the adornment of the decorative principle as immunization against the seething social and gender problems of Austria. Kokoschka had revelled in being the only young talent at the 1908 Art Show to excite press comment, albeit confused comment such as Adalbert F. Seligmann's in the *Neue Freie Presse* (who was to take his verbal hatchet to Schiele a time or two as well): "A side-room containing paintings by Kokoschka, supposedly of a 'decorative' character, should be entered with due care. People of taste will find it shocks their nerves."[22] Even a supporter of the modern such as Ludwig Hevesi could not help calling the Kokoschka space a "wild room". He wrote: "The chief savage is called Kokoschka and the Wiener Werkstätte have high hopes of him. They have also published a book of fairy-tales by him, but it is not for the philistine infant."[23]

Without a doubt, Schiele was familiar with this storybook, Kokoschka's *The Dreaming Boys*, and felt that its repertoire of gestures had something to offer him. We can see as much if we compare the Klimt and Schiele postcard design with Kokoschka's *The Sailing Boat* (in the storybook), or Schiele's *Seer* (1913) with Kokoschka's *The Sailors Call*. But portraits exhibited at the Art Show, such as that of his sister Gerti, also show plainly that the Klimtian decorative style had been adapted in Schiele's usage by the introduction of an angular, unwieldy line such as was already characteristic of Kokoschka's drawings. "People of taste" would not find their nerves shocked, true; but the total relinquishment of a modelled background, and thus of the protective cloak of ornament, heralded a demasking of body and gesture that was gaining in force. And by concentrating on the solo human figure, Schiele proved true to the New Art Group manifesto, dispensing with Klimtian allegorizing and mythologizing and building his own foundation "without reference to the past" or "to tradition". Inevitably, though, Schiele left the Group (after a first unsuccessful New Art exhibition at Vienna's Pisko Gallery) and "went it alone". In a letter to Dr. Josef Czermak in 1910 he stressed that he would shortly be exhibiting "solo" in the Miethke Gallery, and closed the letter with a turn of phrase which gives final expression to the process by which, as an artist, Egon Schiele became his own man: "I went by way of Klimt till March. Today, I believe, I am his very opposite. . ."[24]

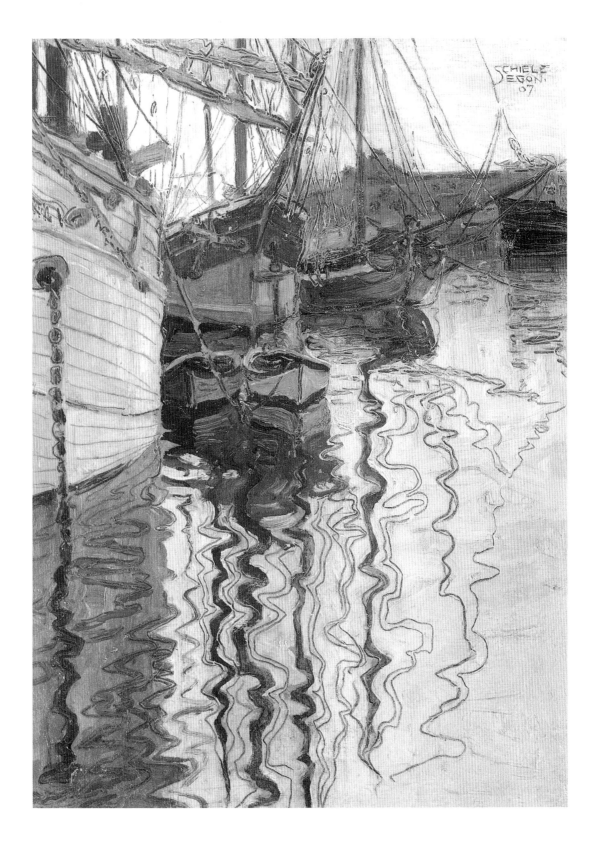

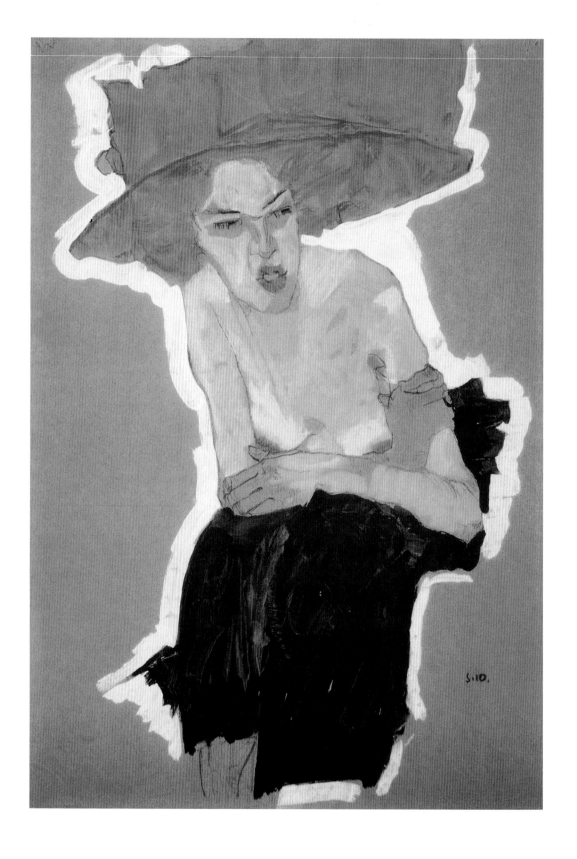

The Figure as Signifier

From 1909 on, Schiele put the elegant linear clarity of a Klimt increasingly behind him and evolved a style in drawing which even his great exemplar Klimt readily acknowledged as the style of a master. The first meeting of the two artists probably took place in 1910. Schiele asked Klimt if they might exchange work, "naively saying that he would gladly give several of his own drawings for one of Klimt's. Klimt replied: 'Why do you want to exchange with me? You draw better than I do anyway. . .' He gladly agreed to the exchange and also bought a few more of Schiele's drawings, which gladdened the latter just as much as the exchange made him proud."[25] Klimt's drawings, even when they record a specific, temporary physical pose, have a more or less self-contained quality; the soft, flowing outline defines the body as an entity, and his drawings only rarely strike us as fugitive in character. Schiele's line, by contrast, seems both frail and clenched. It is often fragmentary, hardly ever straight or even rounded. It breaks off, and becomes more forceful or less so depending on the emphasis that is to be placed on a particular detail. And yet the line is always so assured and controlled that even sceptical critics have to concede Schiele's genius as a draughtsman.

Heinrich Benesch had first-hand experience of Schiele the draughtsman and left a powerful description: "The beauty of form and colour that Schiele gave us did not exist before. His artistry as draughtsman was phenomenal. The assurance of his hand was almost infallible. When he drew, he usually sat on a low stool, the drawing-board and sheet on his knees, his right hand (with which he did the drawing) resting on the board. But I also saw him drawing differently, *standing* in front of the model, his right foot on a low stool. Then he rested the board on his right knee and held it at the top with his left hand, and, *his drawing hand unsupported*, placed his pencil on the sheet and drew his lines from the shoulder, as it were. And everything was exactly right. If he happened to get something wrong, which was very rare, he threw the sheet away; he never used an eraser. Schiele only drew from nature. Most of his drawings were done in outline and only became more three-dimensional when they were coloured. The colouring was always done *without* the model, from memory."[26]

Benesch's account graphically describes Schiele's technical proficiency, but says nothing of the effect this method and his studio practice had on the artistic presentation of his models. With reference to his erotic

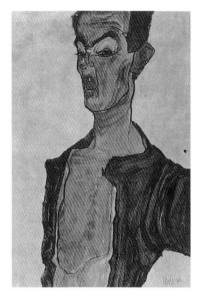

Self-Portrait with Tooth, 1910
Grimasse schneidender Mann (Selbstbildnis)
Gouache, watercolour and charcoal,
44 x 27.8 cm
Private collection

The Scornful Woman, 1910
Die Hämische
Gouache, watercolour and charcoal
with white highlighting, 45 x 31.4 cm
Private collection

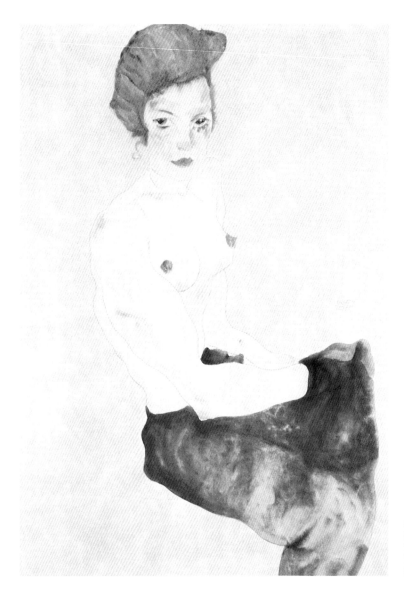

Seated Girl, 1911
Sitzendes Mädchen
Watercolour and pencil, 48 x 31.5 cm
The Hague, Haags Gemeentemuseum voor
Moderne Kunst

drawings in particular, this question is of fundamental significance. Ultimately it is this that determines whether we must see Schiele's art as voyeuristic (as is the case with Klimt).

What first strikes us is that Schiele abandons the normal use of perspective, which would provide a rationale for the positions his figures appear in (p. 10). Anti-academic through and through, subjective to his fingertips, he devises angles and points of view from which the figures will appear twisted, contorted or deformed. What makes many of his watercoloured or gouached drawings *ex-centric* in a core sense is not necessarily or invariably a matter of the subject, of the mere exhibition of nakedness; in formal terms, it derives from Schiele's practice of shifting his

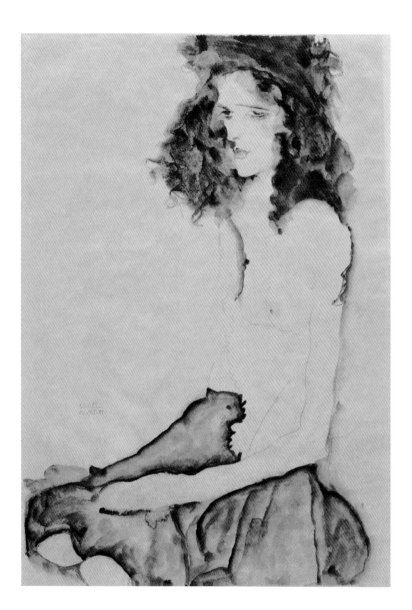

Black-haired Girl, 1911
Schwarzes Mädchen
Watercolour and pencil, 45 x 31.6 cm
Oberlin (Ohio), Allen Memorial Art Museum,
Oberlin College, Friends of Art Fund

figures somewhat out of the centre of the picture, and only rarely view-
ing them frontally or fully. His points of view are many and varied, and
he establishes unfamiliar and alienating poses, bizarre movements (p.
12). If we bear his habit of ruffling conventional ways of perception, it
comes as no surprise when we also learn from Benesch that Schiele
sometimes drew his models from a position on a ladder, occasionally tak-
ing up a vantage point directly above them.

The unusualness of his vantage points has implications that concern
Schiele's intentions, and, with the Klimt comparison in mind, we can
begin to grasp those intentions more clearly now. Klimt's nude girls sug-
gest a situation in which they are indeed alone, behaving as if unob-

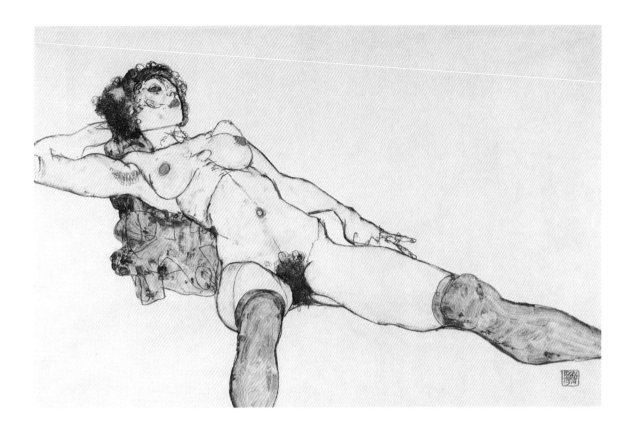

Reclining Woman with Legs Apart, 1914
Liegender weiblicher Akt mit gespreizten Beinen
Gouache and pencil, 30.4 x 47.2 cm
Vienna, Graphische Sammlung Albertina

served. Relaxed, seen in poses that are eloquent of desire, they seem immersed in auto-erotic day-dreams such as are normally the province of male fantasy. This is why we become voyeurs when we look at these nudes: we are entering a private area, seeing things not intended for our eyes, and yet we remain secret, unseen onlookers and are able to retain our own desires undetected. In Schiele's work, on the other hand, similar nudes leave an impression of poses arranged by the artist and subject to his way of seeing (p. 36). This eye is not the "ideal organ of desire" (in the words of writer Peter Altenberg), which it is in Klimt; rather, it is a responsible witness of forced poses which strip the model radically bare and leave her or him exposed and defenceless. These bodies are hardly ever relaxed. Generally they are contorted in a manner almost acrobatic; they are exhibited, put on show, offered up. Schiele (metaphorically) ties his model down on an operating table in his optical lab, and examines the specimen with a clinical gaze, dissecting the creature at his mercy with his pencil. Thus it is that most of his nudes do not seem intimate or absorbed in their own worlds, but instead isolated and tensed (p. 45). What argues against a Klimtian voyeurism in Schiele's nudes is not only the artificial poses but also the models' gaze – frequently they are looking straight at us.

Given the compulsiveness of the daring or even obscene positions Schiele placed his models in, it is hardly surprising that his wife Edith

(who was occasionally his sole model after their marriage in 1915; cf. p. 63) could not permanently satisfy the demands of an artist who knew no taboos, and indeed did not care to. No doubt relieved and resigned, she left the modelling work to professionals after a while. In turn-of-the-century society, artists' models occupied a position close to prostitutes, and could scarcely afford the luxury of self-respect, or of refusing work. One oft-quoted example concerns one of Klimt's models, who was obliged to model for the artist despite (or, from his point of view, because of) the fact that she was well into a pregnancy at the time.[27] Schiele, though, was as forcible in his treatment of male nudes as of female. His attitude to models does not seem to have been representative of usual everyday or studio practice.[28] Still, it was inevitable that a society whose official morality was prudish and bigotted should take offence at his nudes – because of their sheer, aggressive nakedness, which came without the fig-leaf of myth or history and was no more than an obsessive scrutiny of the nude body, and probably still more because of Schiele's unfamiliar and anti-domestic style of presentation, which deprived the viewer of the opportunity to keep a distance.

Schiele's reckless use of very young models, posed nude and (morally speaking) in dubious positions (p. 20), led to the 1912 Neulengbach affair and a brief spell behind bars. In 1910, Schiele and his friend Erwin Osen (1891–1970) had rented a studio at Krumau in southern Bohemia for the first time. In a letter written that year to Anton Peschka, subsequently to become his brother-in-law, he had announced his flight from Vienna and described his aversion to the city: "Peschka, I want to leave Vienna very soon. How hideous it is here! – Everyone envies me and conspires against me. Former colleagues regard me with malevolent eyes. In Vienna there are shadows. The city is black and everything is done by rote. I want to be alone. I want to go to the Bohemian Forest. May, June, July, August, September, October. I must see new things and investigate them. I want to taste dark water and see crackling trees and wild winds. I want to gaze with astonishment at mouldy garden fences. I want to experience them all, to hear young birch plantations and trembling leaves, to see light and sun, enjoy wet, green-blue valleys in the evening, sense goldfish glinting, see white clouds building up in the sky, to speak to flowers. I want to look intently at grasses and pink people, old venerable churches, to know what little cathedrals say, to run without stopping along curving meadowy slopes across vast plains, kiss the earth and smell soft warm marshland flowers. And then I shall shape things so beautifully: fields of colour. . ."[29]

At Krumau Schiele first concentrated on nude studies of himself and of Osen (pp. 48 and 49). It was not till the following year that his longing to create "fields of colour" was expressed in a number of landscapes. In 1911 he returned to Krumau, this time with Wally Neuzil, who had formerly modelled for Klimt and with whom Schiele was to spend the next few years. It was not long before Schiele was driven out of Krumau, though, on account of his free lifestyle with Wally and his drawings of young girls. Since he still needed an alternative to the "dead city" of Vienna he moved that same year to a reasonably-priced house in the

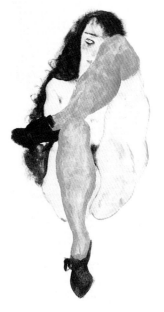

Female Nude with Green Stockings, 1912
Weiblicher Akt mit grünen Strümpfen
Gouache, watercolour and pencil,
48.2 x 31.8 cm
Private collection

PAGES 38/39:
Nude Woman Lying on her Stomach, 1917
Am Bauch liegender weiblicher Akt
Gouache and black chalk, 29.8 x 46.1 cm
Vienna, Graphische Sammlung Albertina

37

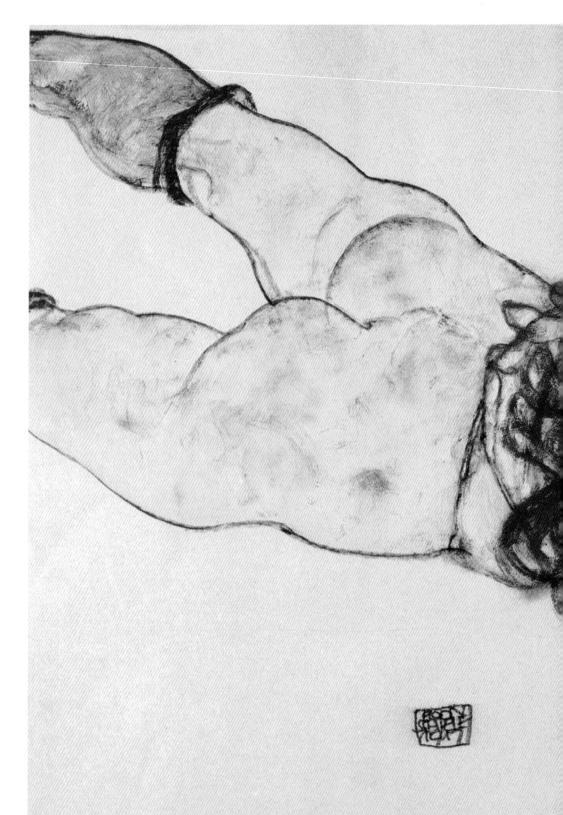

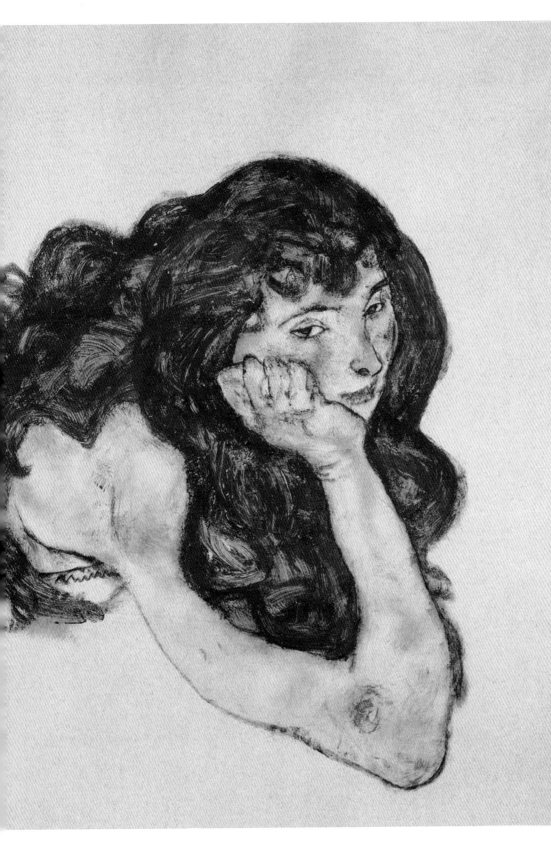

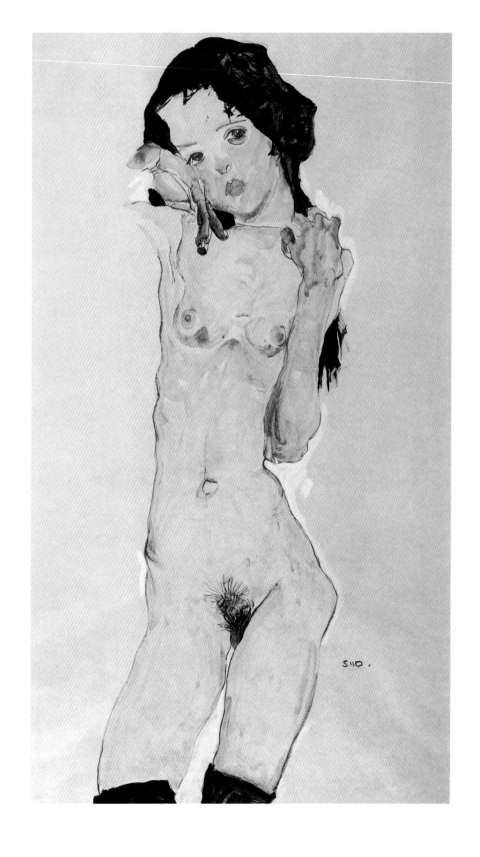

country at Neulengbach, west of the capital. Letters to his one-time guardian, Uncle Leopold Czihaczek, and to collector Dr. Oskar Reichel indicate that Schiele had now evolved a solipsistic philosophy of life that appeared to render both his art and his own life as an artist immune to misunderstandings and to philistine attacks. He penned aphorisms, and the blend of pride and naive messianic feeling speaks for itself: "Artists will live forever. – I always believe that the greatest painters painted the human figure. . . – I paint the light that emanates from bodies. – Erotic works of art are sacred too!. . . – A single 'living' work of art will suffice to make an artist immortal. – My pictures must be placed in buildings like temples."[30]

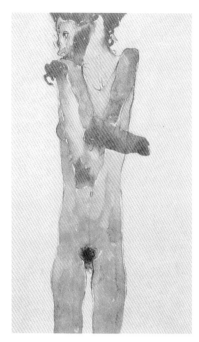

Nude Girl with Crossed Arms (Gerti Schiele),
1910
Mädchenakt mit verschränkten Armen (Gertrude Schiele)
Watercolour and black chalk,
48.8 x 28 cm
Vienna, Graphische Sammlung Albertina

The canonization of his erotic art was unable to prevent Schiele's arrest, at Neulengbach, on 13 April 1912. His drawings were confiscated and he was accused of "seducing" and "violating" an under-age girl, charges that were dropped at the trial in St. Pölten. In the event, Schiele was given a three-day prison sentence for displaying immoral drawings where they were visible to children, a sentence which took into account the fact that he had already spent three weeks in custody by the time of the trial. According to Benesch, the charge of immorality originated as follows: "Good-natured as he was, Schiele, when he had finished drawing child models, would often let whole hordes of boys and girls, the models' schoolfriends, come into the room and romp about. Schiele had pinned up on the wall only one single wonderful sheet in colour, of a very young girl clothed only from the waist up. Children who were no longer wholly innocent would whisper about it, and talked, and that was how the charges came about. – The beautiful drawing was subsequently destroyed at the order of the court."[31]

In 1922, four years after Schiele's death, Arthur Roessler published an account of the affair under the title *Egon Schiele in Prison*; written in the first person, it purported to be an authentic version, and did much to establish a romanticized image of a misunderstood artist. But it has now been shown that Roessler's version was largely his own invention[32]. In part he used texts that Schiele had written to accompany thirteen works done in prison, presenting them as statements made by Schiele. These texts were certainly well suited to presentation as gestures of heroic resistance made by a misunderstood genius. In several of these watercolours, Schiele himself appears as a worn, shorn victim, his fearful and tormented expressions eloquent of the terrors of isolation and imprisonment, a victim who nonetheless remained true to his mission, and spoke the "truth". "I FEEL PURIFIED RATHER THAN PUNISHED," Schiele wrote on one drawing, and on another: "TO HINDER AN ARTIST IS A CRIME, TO DO SO IS TO MURDER BURGEONING LIFE," and on another: "I SHALL GLADLY ENDURE THIS FOR ART AND FOR MY LOVED ONES" (pp. 52 to 55).

From a compositional point of view, the Neulengbach drawings can be seen as extreme examples of expressional experiment, with his own person as Schiele's preferred subject. The poses are artificial, and most of them use heavily exaggerated gestures and facial expressions. It is worth pointing out that this highlighting of the expressive repertoire is less ex-

Standing Nude Girl, 1910
Schwarzhaariger Mädchenakt (stehend)
Watercolour and pencil, with white highlighting,
54.3 x 30.7 cm
Vienna, Graphische Sammlung Albertina

Three Street Urchins, 1910
Drei Gassenbuben
Pencil, 44.6 x 30.8 cm
Vienna, Graphische Sammlung Albertina

treme in the pictures of women, or else is achieved by other means. It is time we took a closer look at the nature and possible sources of Egon Schiele's expressive idiom. Is there a kind of grammar of gestures which will enable us to read the generally bewildering gestures as we would read language signs and to attribute specific meanings to them?

Schiele scholarship has long held that the artist's oeuvre is based on a very private mythology drawn from the unconscious. Roessler, who considered himself Schiele's confidant, wrote in a 1913 catalogue foreword that "personal contact with Schiele does not provide any clues to the solution of certain puzzles in his art" either. That art, wrote Roessler, was "a monologue, and in a sense manic, demonic". Some of Schiele's pictures were "the materialization in a darkened consciousness of bright apparitions"[33]. If we take into account Schiele's reserved nature, his leanings to the esoteric and mystical, and his rejection of the legacy of culture and handed-down symbolism, we shall have to concede that much must remain enigmatic[34]. The gestures and facial expressions of his figures, however, inscrutable and even impenetrable though they may be, do share certain characteristics with other cultural phenomena and may conceivably have been inspired by them.

It is Roessler's account that contains our first pointer to Schiele's general interest in stylized, expressive figures. Roessler mentions Schiele's interest in exotic figures, in particular the painted puppets used in Javan shadow theatre: "He could play with these figures for hours on end without tiring of them or saying a word. What was really astonishing was the skill with which Schiele manipulated the slender sticks that move the puppets from the very outset. When I offered him the choice of any Javan shadow puppet, to give him a small pleasure, he chose the grotesque figure of a diabolical demon with a rakish profile. This figure inspired him more than once. He was fascinated by the strictly stylized, often magically vivid shadow outlines on the wall. 'A figure like this can do more than our best dancers. Compared with my red demon, Ruth' (he mentioned a famous dancer) 'is a clod-hopper'. So said he, and he gave his buffalo-hide demon a loving look. This Javanese figure remained his favourite plaything till his death."[35] The famous dancer in question was Ruth Saint Denis, for whom Schiele (according to another friend, Fritz Karpfen) had a special admiration – which the "jealous" Roessler did not care to admit. One way or another, a variety of expressive figures can leave us in no doubt that mime and expressive forms of dance, and in a wider sense all things theatrical, left a deep impression on Schiele.

Before the turn of the century, dancer Loïe Fuller caused a sensation. Her style of dance was strikingly different from that of the next generation, dancers such as Isadora Duncan, the Wiesenthal sisters, Mary Wigman or Ruth Saint Denis. An 1893 lithograph by Toulouse-Lautrec showing Fuller at the Folies-Bergère shows why she was called an artist in colour. The appeal of her dancing lay "not in the movements of her limbs but in the swing of the folds of her dress, which was flooded in colourful light. She offered a choice performance; but the huge success of the serpentine dance was due not to the dance itself but to the lighting artist."[36] Her dancing suited the world of the Impressionists perfectly, and

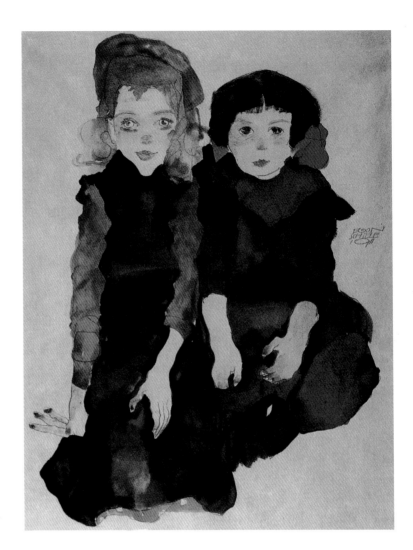

Two Young Girls, 1911
Zwei kleine Mädchen
Gouache, watercolour and pencil, 40 x 30.6 cm
Vienna, Graphische Sammlung Albertina

the whirl of her filmy draperies afforded a foretaste of Art Nouveau. The
twentieth century saw the arrival of a new dance star, Isadora Duncan.
Max von Boehn snidely described her as a "dancing governess", claimed
that when she moved her arms and legs she was "catching flies", and as-
serted that her performance "did not add up to a whole, to anything
moved by inner necessity". Critic Ludwig Hevesi was less unpleasant
and doubtless fairer when he wrote: "These dances are not properly
speaking dances at all. Rather, they are mimed actions."[37] Yet Isadora
Duncan played a vital part in the modern evolution of dance, not least on
account of her belief that the body could only move naturally when
naked. Duncan's mission was to body forth the sacredness of the female
body; a different passage in Hevesi indicates where Ruth Saint Denis's
priorities as a dancer lay – the entire passage is full of erotic innuendo.
Hevesi is in raptures over "the unusual talents of her wrists and the deep

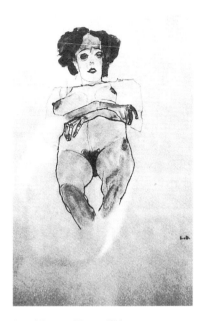

Seated Pregna.. Woman, 1910
Sitzender schwangerer Akt
Gouache, watercolour and black chalk,
44.8 x 31.1 cm
Private collection

Female Nude, 1910
Weiblicher Akt
Gouache, watercolour and black chalk
with white highlighting, 44.3 x 30.6 cm
Vienna, Graphische Sammlung Albertina

soulfulness of the groove down her spine", and enthuses: "She plays the serpent. With her two snakelike arms twisting about her, she stretches, flexes, coils, sidles in arabesques and then recoils. . ."[38]

Graphic though the description is, they are still only words, alas, conveying a mere impression of what Schiele prized so highly in Ruth Saint Denis. Perhaps it was her acrobatic movements, perhaps the mysterious eroticism which had no need of words in appealing to the senses. There remains a difference between his kind of expressive art and this style of dance: in Schiele, there is neither deliberate symbolism nor unambiguously lascivious meaning in the movements. His figures use a repertoire of angular gestures and fleeting facial expressions and aim at an affective state that can verge on the pathological.

This said, then, it seems that a third source of inspiration may have been the richest for Schiele. This was his contact with the mentally ill. His interest in the pathological body language of the mentally ill had been aroused by his friend Erwin Osen (also known as Erwin Dom Osen or Mime van Osen; cf. p. 48). Osen, commissioned by one Dr. Kronfeld, had done drawings of mental patients at the Steinhof asylum for a lecture on pathological expressions in portraits[39]. In the few sources we have, Osen makes a distinctly eccentric impression. Like Schiele he was a member of the New Art Group founded in 1909; he earned his living as a stage set painter, and seems at points to have influenced Schiele so considerably that certain supporters and patrons came close to being insulting in their comments on him. Roessler labelled him a "fallen angel", though conceding the mimic virtuosity which he dazzlingly displayed on the variety stage. Both in private and in the coffee houses he dressed to be noticed and put on affected facial expressions, as certain of Schiele's drawings plainly show (p. 49). His exotic girl-friend Moa, who gave herself Egyptian-style airs, apparently made quite an impression on Schiele too. The extent of Osen's influence on Schiele is difficult to determine with any finality; but it is certain that his over-the-top personality and manner bear an unmistakable affinity to Schiele's expressive figures. The strongest link between them, however, was their shared interest in pathological expression.

This interest may seem a curious one at first glance, but it has an artistic tradition. In the 18th century, for instance, quite apart from William Hogarth or Francisco Goya, we find the sculptor Franz Xaver Messerschmidt doing an entire series of "character busts", the physiognomy so overdrawn that the expressions surely come close to the pathological. For a long time, Messerschmidt himself was considered a lunatic, a judgement which missed the fact that he was an artist out to record conceivable varieties of expression: the endeavour, which called for discipline and control, aimed at an experimental extension of the conventional physiognomical canon, as far as the grotesque and pathological. Schiele may well have seen these busts in Vienna and been inspired by them. Nineteenth-century examples include Théodore Géricault's painting *Insane Child Kidnapper* (1822/23) and Wilhelm von Kaulbach's *House of Fools* (1834). For many 19th century painters, using criminals or the mentally ill as models seemed a special way of defining and repro-

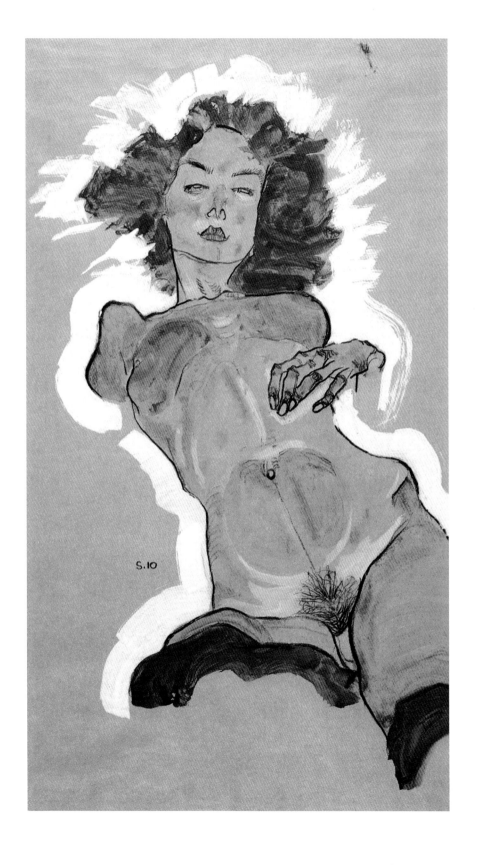

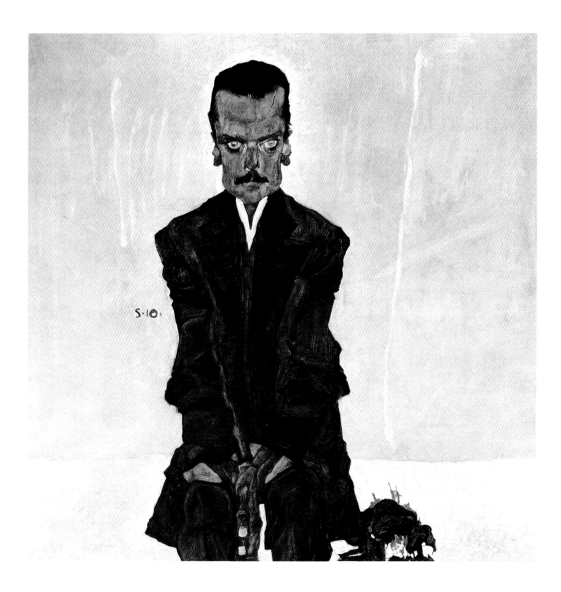

Eduard Kosmack, 1910
Oil on canvas, 100 x 100 cm
Vienna, Österreichische Galerie

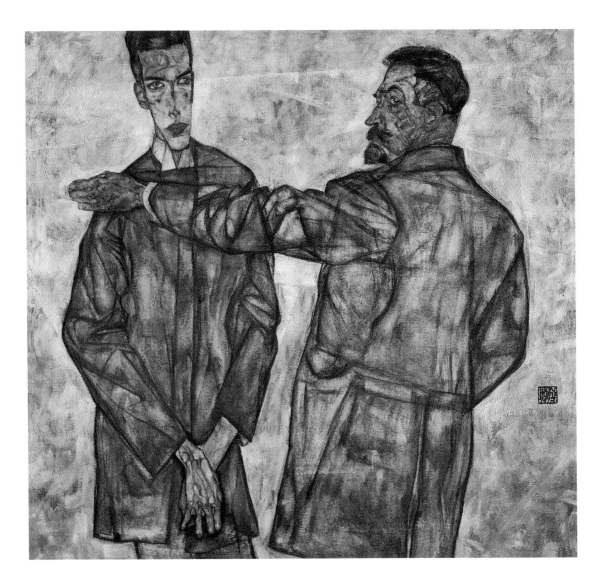

Heinrich and Otto Benesch, 1913
Oil on canvas, 121 x 131 cm
Linz, Neue Galerie der Stadt Linz,
Wolfgang-Gurlitt-Museum

Mime van Osen, 1910
Watercolour and charcoal, 37.8 x 29.7 cm
Graz, Neue Galerie am Landesmuseum
Joanneum

ducing the states of mind that determine character by way of facial expression.

Positivist medical science in the 19th century believed that enquiry into spiritual truth, and the quest for a link between character and physiognomy, could be placed on a secure scientific footing if verifiable experiments were conducted. Charles Darwin was impressed by Duchenne's *Mechanism of Human Physiognomy* (1862), which reported the electrical analysis of the movement of facial muscles and was superbly illustrated with photographs. And yet, Darwin noted, Duchenne only rarely tried to explain why certain muscles were moved under the influence of certain states of emotion rather than others. Darwin attempted an explanation himself in *The Expression of the Emotions in Man and Animals* (1872). This appeared in German translation in the year of its original publication; but it has yet to be established whether there is any tangible link between the scientific analysis of expression contained in such works and the artistic presentation of expression undertaken by a Kokoschka or a Schiele.

The link is clearer in the case of drawings done in the 1880s by Dr. Paul Richer, assistant to Jean-Martin Charcot, the renowned Paris neurologist. The drawings aim and claim to define precisely distinguishable pathological phases and their typical features. In this case we can trace the path that may have led to a Viennese artist's expressive repertoire fairly closely. This is not to say that Schiele saw all or many of his models (himself included) as hysterics, or that he deliberately posed them as such. But we must note that his models (and Schiele himself) are often striking for the ecstatic or clenched quality of their movements – movements that cannot be ascribed to any definable emotional state and which bear a certain resemblance to Charcot's or Richer's "mannequin". The term "mannequin" was later applied by a critic to Augustine, Charcot's favourite subject for examinations and demonstrations. And the term was by no means inapt: Charcot himself referred to his institute as a "living pathological museum". Furthermore, in the field of psychiatric research it was Charcot who made the most radical use of the eye as an instrument in medical insight. Unfortunately he placed too much faith in the seeming objectivity of his proofs (drawings, and the camera), which at that date were promoted to the scientist's true retina: he succumbed to the aesthetic qualities of his female patients' movements and uplifted facial expressions. Far later than the mid-19th century, hysteria was still considered unknown medical territory. "The symptoms of this perplexing illness had no demonstrable cause: autopsies revealed no material cause in the body. Charcot, who had held the chair in neuropathology at the Salpêtrière in Paris since 1882, tried to prove that hysteria was nevertheless an illness that had to be taken seriously and not merely treated as simulation or play-acting as was generally the case. He succeeded by means of hypnosis: suggestion could produce hysterical paralyses, in men (incidentally) as well as in women. These displayed the same symptoms as so-called traumatic forms of hysteria, which resulted from lesions of the nervous system. As is well known, however, Charcot did not draw the inference that hysterical paralyses and contractures were attrib-

Man in a Felt Hat (Erwin Dominik Osen), 1910
Männerporträt mit Schlapphut (Erwin Dominik Osen)
Watercolour and black chalk, 45 x 31 cm
Private collection

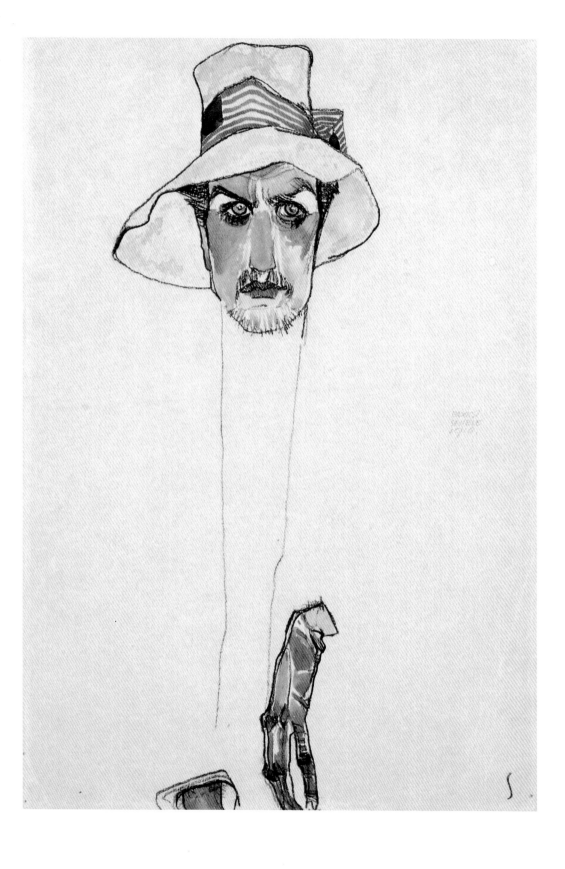

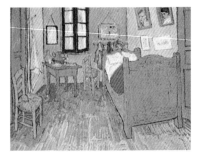

Vincent van Gogh
The Artist's Bedroom at Arles, 1889
Oil on canvas, 56.5 x 74 cm
Paris, Musée d'Orsay

utable to the effects of mental traumas." It was left to Josef Breuer and Sigmund Freud, who studied with Charcot in 1885, to recognize "that hysterical attacks are innervations produced by unconscious fantasies". Charcot, by contrast, presupposed that "every pathological occurrence is expressed on the surface of the hysterical body" and that the eye of the doctor, registering and comparing, was therefore the perfect instrument of diagnosis. It was for this reason that Freud called Charcot a seer (*visuel*).[40]

Charcot thought he could define a rule governing hysterical attacks, and identified four phases: 1. the epileptoid; 2. the clownish, a phase of non-specific movements, one of which is the arched spine associated with bouts of hysteria; 3. a period of passionate gesture; and 4. a phase of delirium or of hysterical ecstasy. This last was the most theatrical part of the entire attack, in which countless gestures, gesticulations and facial expressions marked the transformation of the hysteric's hallucinations into poses. These poses were recorded by Charcot and Richer in labelled tables and series of photographs, to constitute a kind of grammar of the human figure. To their astonishment the two doctors found that similar phenomena could be seen in historical paintings and graphic artworks. The fruits of their iconographical investigations were published in *Les démoniaques dans l'art* (1887), in which, among other things, they took the portrayal of a man possessed in Rubens' *Miracle of St. Ignatius of Loyola* (1617) as an illustration of a major hysterical attack. In October 1901 (the link with Vienna is becoming clearer) there was a Rubens exhibition at the Albertina, and in the course of a review Ludwig Hevesi demanded: "The Secession and Rubens! What is the connection between them?" The answer was that Rubens had portrayed neurosis and hysteria with amazing fidelity – it had to be true, otherwise he would hardly have been included in Charcot and Richer's book![41]

In comparing the character of his patients' illness with historical portrayals of the possessed in the visual arts, and discerning certain similarities which he meticulously classified and catalogued, Charcot was not only misunderstanding the symbolic structure of hysteria. In the expressive attacks of hysterics he detected symptoms that made them objects of aesthetic appreciation; time and again he speaks of "beautiful" cases and instances. And an aestheticizing effect is also achieved when the two writers assert: "Hysteria is not a pathological phenomenon, but can in every respect be considered a high means of expression."[42] This, among other things, constitutes the reason why hysteria to some extent became a work of art and the hysterical woman an actress whose repertoire of gestures offered the sheer artistry of nerves. As well as going to Charcot's lectures, Freud went to see the actress Sarah Bernhardt perform, and referred to her strange bodily poses. Bernhardt was renowned for her extremely emotional, eloquent body language and attitudinizing. Her style of acting marked the definitive entry of a pathological phenomenon into the higher realms of culture. Even if it did not do so by a direct route, the gestural repertoire of hysterics could become an inspiration by indirect means, via the stage. And at all events we can say that Charcot and Richer's aesthetic appraisal of hysterics was the vanguard in

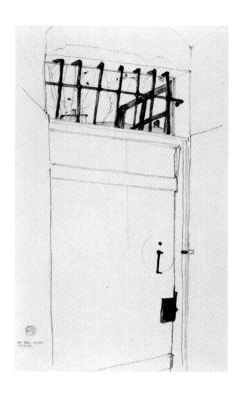

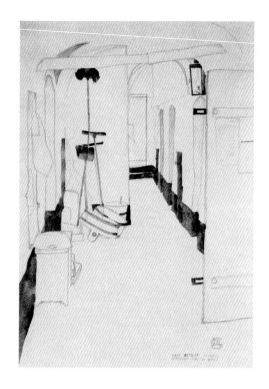

ABOVE LEFT:
Cell Door, 1912
Die Tür in das Offene!
Watercolour and pencil, 48.2 x 32 cm
Vienna, Graphische Sammlung Albertina

ABOVE RIGHT:
Prison Corridor, 1912
Nicht gestraft, sondern gereinigt
fühl' ich mich!
Gouache, watercolour and pencil,
48.4 x 31.6 cm
Vienna, Graphische Sammlung Albertina

LEFT:
Two Handkerchiefs on a Chair, 1912
Zwei meiner Taschentücher
Watercolour and pencil, 48.2 x 31.7 cm
Vienna, Graphische Sammlung Albertina

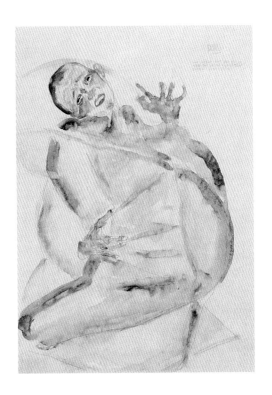

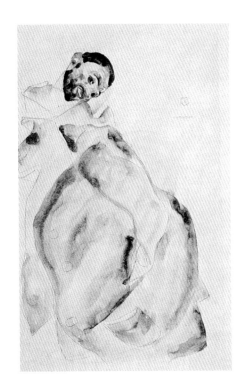

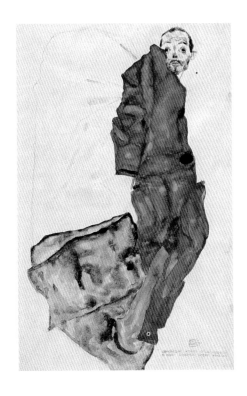

ABOVE LEFT:
Self-Portrait as Prisoner, 1912
Ich werde für die Kunst und für meine
Geliebten gerne ausharren!
Watercolour and pencil, 48.2 x 31.8 cm
Vienna, Graphische Sammlung Albertina

ABOVE RIGHT:
Self-Portrait as Prisoner, 1912
Gefangener!
Watercolour and pencil, 48.2 x 31.7 cm
Vienna, Graphische Sammlung Albertina

RIGHT:
Self-Portrait as Prisoner, 1912
Den Künstler hemmen ist ein Verbrechen,
es heisst keimendes Leben morden!
Watercolour and pencil, 48.6 x 31.8 cm
Vienna, Graphische Sammlung Albertina

an evolution that was to peak in March 1928 when Louis Aragon and André Breton published an ironic article commemorating "the fiftieth anniversary of hysteria" in their magazine *La revolution surréaliste*[43].

If we consider all of this in its broader cultural context, Charcot and Richer's examination of the expressive characteristics of the possessed and hysterical is only one more symptom of the aesthetic upgrading of phenomena which until the 19th century had rarely been dealt with at all and were considered unworthy of visual treatment except in purely negative terms. Their approach illustrates the officious, scientific side of an interest in the pathological, in things that did not conform to societal norms, which we find in the literature of Baudelaire, Rimbaud or Huysmans.

The German critic Max Nordau coined the fateful term *Entartung* (degeneration),[44] a term later used to baleful effect by the Nazis, and thus made it possible to damn all things foreign to the norm as sick. It was an accusation Schiele had to be defended against too. In May 1912 Arthur Roessler examined the "angry yapping" of the philistines, attempting to explain their response to Schiele in terms of fear: "Some of Schiele's portraits showed them that he was able to reveal the inner self of a person on the outside, and they were horrified by the thought of seeing things that are carefully kept hidden, things urinous and crawling with vermin and eaten away with corruption. Egon Schiele has seen and painted human faces that have a pale sheen and a pained smile and are like the faces of vampires deprived of their gruesome nutrition; faces of the possessed, their souls festering, their unutterable suffering turning to a mask-like rigidity; and faces that delicately offer a visual account of an entire human inner life, with all the subtle nuances in the visible expression of brooding, deliberation, meditation, dreaminess or passion, evil, good, the heartfelt, the warm and the cold. He has seen and painted eyes as cold as gems in human faces ashimmer with the pallid colours of decay, and he has seen death beneath the skin. Astounded, he has seen clenched, deformed hands with creased skin and yellow nails . . . But it would be a misunderstanding to think that he paints it all out of sheer predilection . . ."[45]

To sum up, Schiele was an artist whose interest was mainly in expressiveness as seen in gesture and facial expression. His figures are revelations of pathos, of sorrowful emotion, whose epiphanies occur not in communicative formulae but in eruptive convulsions and contorted grimaces. He turned from the blasé, stylized portrayal of humanity cultivated by Vienna Jugendstil (i.e. Art Nouveau); but nonetheless, humanity is not free in Schiele either, becoming instead a helpless puppet at the mercy of powerful, affective forces.

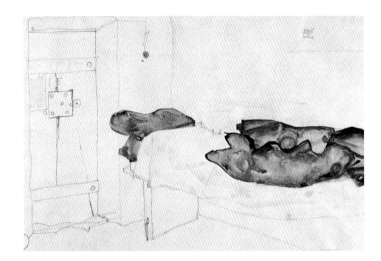

The Orange, 1912
Die eine Orange war das einzige Licht
Gouache, watercolour and pencil, 31.9 x 48 cm
Vienna, Graphische Sammlung Albertina

Chairs, 1912
Kunst kann nicht modern sein; Kunst ist urewig
Gouache, watercolour and pencil, 32 x 48.3 cm
Vienna, Graphische Sammlung Albertina

Overturned Chair, 1912
Organische Bewegung des Sessels und Kruges
Watercolour and pencil, 31.8 x 48 cm
Vienna, Graphische Sammlung Albertina

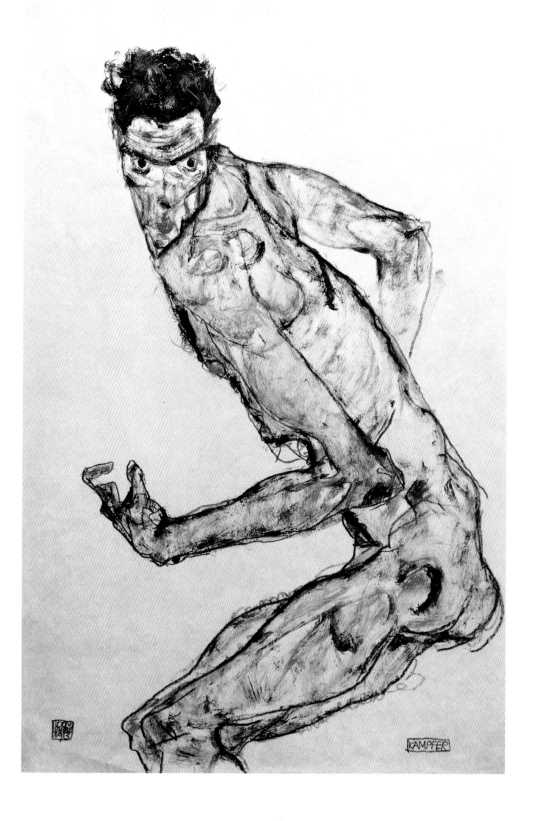

KÄMPFER

The Visionary and Symbolic Works

Though Schiele dramatized his prison experience, the Neulengbach affair seems to have had no lasting ill effects on his personality. True, for a month or so his output was diminished. And he travelled to Carinthia and then Trieste – though not so much to escape an unpleasant memory as for the sheer pleasure of travel and to recover. Nor did the affair do any damage to his career. In January 1912 he exhibited in Budapest, in February and March at Hans Goltz's in Munich, then at the Hagenbund in Vienna; and only a short while after the affair he had three paintings in the famed Sonderbund show in Cologne. What was more, in 1912 further important collectors took an interest in his work – which made a distinct improvement in Schiele's financial situation. As well as Franz Hauer, who also supported Kokoschka, he made the acquaintance of industrialist August Lederer. Lederer even invited him to Györ for the Christmas period to paint a portrait of his son Erich. Letters Schiele wrote from Györ to his mother and to Roessler clearly show how flattered Schiele felt by the art-loving Lederer family's admiration. But they also show that his bright mood was influenced not least by his host's genteel lifestyle. Schiele, who came of a family that was anything but well-to-do, had satisfied his taste for fashion as a youngster by cutting out his own paper collars, and regularly invested the proceeds of his sales in expensive clothes rather than banal everyday necessities; so it was small wonder that he took to the carriage (always at the ready) and to the servants wearing grey livery with silver buttons[46]. The remarkable contrast of young dandy and ascetic artist (whose work was far from offering comfortable stylishness for the upper crust) can be seen in a number of photographs of Schiele taken in 1914, which document his penchant for vain posing. We shall be coming back to this.

In 1913 Schiele's career success was consolidated: he became a member of the Federation of Austrian Artists (the president was Klimt) and once again exhibited at important shows, among them the Vienna Secession's International Black and White Exhibition, the Folkwang Museum in Hagen, and again at Hans Goltz's in Munich. Thanks to Goltz and Roessler, some of his works were also seen in Hamburg, Breslau, Dresden, Stuttgart and Berlin. In Berlin he came to the attention of Franz Pfemfert, founder and editor of *Die Aktion* (p. 57), an Expressionist, left-wing periodical. Pfemfert subsequently offered Schiele a number of commissions, and in 1916 even devoted an entire number of the magazine to

Title page of the Berlin periodical
‹*Die Aktion*›, 1916
Vienna, Graphische Sammlung Albertina

Fighter, 1913
Kämpfer
Gouache and pencil, 48.8 x 32.2 cm
Private collection

Schiele. Like Kokoschka in Herwarth Walden's journal *Der Sturm*, Schiele was thus in a position to have his work seen in a widely-read publication.

In spring 1914 Schiele, perhaps partly on the strength of his work for *Die Aktion*, allowed Roessler to talk him into taking etching instruction with Robert Philippi. He only took two months of tuition, though. Compared with his preferred medium of drawing, which is more spontaneous and which Schiele had a sure grip on, etching seemed a protracted, dull technique. In the event, he produced only seventeen etchings – though some of them, notably a sheet titled *Worries*, show that he had learned quickly and had unusual talent at etching.

Schiele found photography infinitely more interesting, and from time to time took photos himself. He did not see photography as an artistic medium in its own right, which might supplement or even replace drawing and painting, but it still offered an ideal tool for one as fond of posing as Schiele (p. 7). In most of the pictures taken by Anton Josef Trčka and some by his studio neighbour Johannes Fischer, Schiele is seen striking poses that bear a strong resemblance to the expressive studies he drew and painted. Plainly he did not see himself as a mere cog in some impersonal machine; rather, by deliberately affecting artificial gestures and facial expressions he made a work of art of his own person. It is no coincidence that he reworked one of these photographs and even signed it repeatedly. Almost all the portraits show a young man, stylish and self-confident yet free of affectation, at times pulling Dadaist faces, at other times looking serious and pensive, but certainly not aiming to look the artist or craftsman – the image he is out to convey is that of the sensitive quester after a personal identity. This is expressed most eloquently in a double-exposure showing Schiele from two different angles (p. 18).

At other times, in a 1915 Fischer photograph for instance, what we see does look rather more like self-infatuation than profound intentions, alas. Generally speaking, Fischer's photos are of lesser aesthetic value, but they are interesting in that they document the collector in Schiele. In one shot we see Schiele in front of a Wiener Werkstätte cabinet (p. 95) filled with an assortment of curious collectables: a small Union Jack, exotic and folk art, oriental (particularly Japanese) woodcuts – Schiele was rumoured to possess the best collection of Japanese pornography in Vienna[47] - and, amidst various other items, the *Der Blaue Reiter* almanac. All in all, it is a collection of odd and worthless things that tell us a fair amount about the sources of Schiele's inspiration.

This was one side of Egon Schiele: an inquisitive young man, interested in fashion, vain, keen to travel. "The other side" (to borrow the title of Alfred Kubin's disturbing, fantastic novel published in 1909) is the dark, seemingly melancholy artist, that Schiele whose works up to around 1914/15 tended to be loaded down with enigmatic, symbolic titles reminiscent of Nietzsche's *Thus Spake Zarathustra*. *Seer* or *Caller* or *Fighter* (p. 56) are the labels attached to figures drawn in 1913 whose attitudes are reminiscent of the transports and ecstasies of ritual ceremonies. Titles of paintings are *Agony* (p. 73), *Cardinal and Nun*, *The Hermits* and *Vision and Fate* - paintings in which Schiele approaches

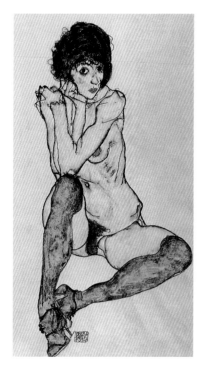

Seated Woman with Elbows on Knees, 1914
Sitzender Mädchenakt
Gouache and pencil, 48.3 x 32 cm
Vienna, Graphische Sammlung Albertina

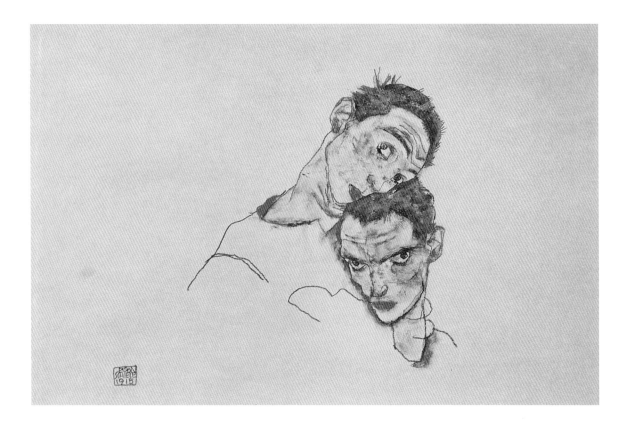

fundamental questions of life and death, presenting them in a mystical or (as it were) religious fashion. "I know there is no such thing as modern art. There is only art that abides forever,"[48] Schiele had written in 1911, indicating that his own approach to seeing and representation owed nothing to the Impressionists' insistence on the retina or to current movements either. He saw himself hieratically, as a priest-like seer with an inner capacity for experience that verged on the mystical, a capacity that enabled him to see and fashion visions. In one of his poems he gave forceful expression to this:

"He is above all an artist / who has great spiritual gifts, / he who expresses / views of / conceivable phenomena / in nature . . . Artists are quick to sense / the great trembling light, / the warmth, / the breathing of living creatures / the coming and going . . . They are the chosen ones, / fruits of Mother Earth, / the kindliest of humanity. They are easily excited / and speak a language of their own / . . . But what is genius? / Their language is the language of the gods / and they dwell here in paradise. / This world is paradise to them. / All is song / and like unto the gods . . . All that they say / they need have no reason for, / they speak it, / it must be so – because they have the gift. / They are explorers. / Divine, highly gifted / versatile, omniscient – / modest living beings. / Their polar opposite is the prosaic man, / the everyday man."[49]

Such views place Schiele in that 19th century tradition that saw the ar-

Double Self-Portrait, 1915
Doppelselbstbildnis
Gouache, watercolour and pencil,
32.5 x 49.4 cm
Private collection

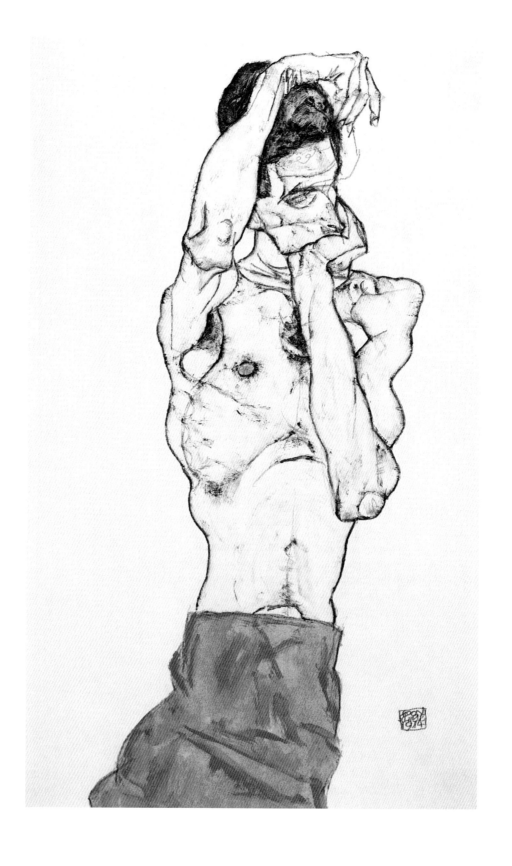

tist as a species of prophet, saint or martyr (p. 19). He is particularly close to Ferdinand Hodler, who, under the influence of the Rosicrucians, gave his paintings mystical titles laden with pathos, such as *The Disillusioned Ones, The Way of the Chosen Souls* or *The Chosen One.*

The Schiele works referred to above, scarcely accessible to a full interpretation, generally use either one or two figures. There is never any narrative frame, and the content and meaning are thus beyond the categories of an event or chronologically unfolding action. We are entirely in a realm of sensation and expression which conceptualization can only approximately grasp. Schiele himself, in a letter written in 1912, offered an explanation of his painting *Revelation* (whereabouts unknown). He very rarely tried to explain himself, and this attempt is therefore all the more welcome if we are to understand his way of thinking: "Dear Dr. E., 'Revelation'! The revelation of a living being. A poet, an artist, a sage, a spiritualist, as you will. – Have you ever felt the impression a great personality makes on the world? – This is one such. – Pictures must emanate light, bodies have light of their own which they use in the course of living; they burn up, they are unlit. – The figure behind? – The one half represents the vision of a man so great that the one who beholds him kneels down, ecstatic, bowing to that greatness which looks on with eyes closed, decaying, the astral light emanating in orange or other colours, so intensely that the bowed figure is hypnotized and flows into the great one. – To the right, all is reddish orange, reddish brown. – To the left is the being similar but different, equal to the great one on the right. (Positive and negative electricity complement each other as a new whole.) Thus the small kneeling figure is melting into the radiant great one. – These are some comments on my picture 'Revelation'. Egon Schiele."[50]

For these paintings, Schiele often chose a square or almost square format, which lent them a vivid quality that was singularly apt. A square format dictates no focus and thus tends to place the subject in the centre, establishing a hierarchical structure rather than a narrative sequence. This concentration has another effect: the subject(s) of the picture are not only fixed in a frozen attitude, but are also isolated from any environment, and so exposed. The figures are not so much located in optical perspective (depth) as placed within the coordinates of an emphatically *painted* surface. This surface is segmented in near-geometrical colour zones which subject Klimtian decorativeness to a quasi-Cubist revision. The lack of focus and the spatial splitting into surfaces convey a certain tentativeness, a quality of suspension in the figures – as if only their presence within the system of coordinates gave them any secure anchorage. *Soaring* (1915) is an almost programmatic paradigm of this visionary core mood.[51]

Admirers such as Roessler acknowledged Schiele's iconographically cryptic and off-beat works by referring to his "intuitive, sleepwalker's way of working" which at times "succeeded in creating works that are far beyond his own rational judgement"[52]. Other, sceptical critics such as Friedrich Stern accused Schiele of "hungering after the weird and abstruse", of imitating the latest "horrible" fashions – even the "methods of the Cubists"[53].

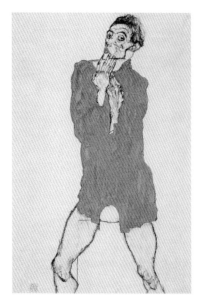

Self-Portrait in Shirt, 1914
Selbstporträt im Hemd (Kniestück)
Gouache and pencil, 48.5 x 32 cm
Stuttgart, Staatsgalerie, Graphic Collection

Standing Male Nude with Red Loincloth, 1914
Stehender männlicher Akt mit rotem Lendentuch
Gouache, watercolour and pencil, 48 x 32 cm
Vienna, Graphische Sammlung Albertina

Wally, 1912
Gouache and pencil, 29.7 x 26 cm
Lengenfeld Castle, Christa Hauer-Fruhmann

Edith Schiele, 1915/16
Edith Schiele im gestreiften Kleid
Oil on canvas, 180 x 110 cm
The Hague, Haags Gemeentemuseum voor
Moderne Kunst

In Schiele's visionary and symbolic works, the mother pictures occupy a special position. They are as inaccessible to ready classification in terms of traditional iconography as the self-portraits and the "Nietz-schean" motifs. And without a knowledge of the specific problems in Schiele's relation with his own mother we will find them forever an enigma.

In his first venture upon this territory, the 1908 *Mother and Child* (p. 74), we see Schiele at work on a conventional theme. Yet even here the interpretation has a personal slant. Schiele may have been influenced by a 1903 painting by Elena Luksch-Makovsky, a self-portrait together with her son Peter. Luksch-Makovsky availed herself of the time-honoured iconography of the Virgin, thus transposing her own mother-son situation to a more general, higher level; Schiele, however, dealt subjectively with the theme. Perhaps unconsciously, he used the conventional theme as a pretext to make a hierarchical distinction between the roles of mother and child. The woman, whose exact identity remains unspecified, is wrapped in a dark cloak and hallowed by a weak aura. Her eyes glow magically. In her lap she is holding a child who, in contrast to the mother, is fully lit and makes a far more solid impression – not in a simplistic, realistic sense, but in the sense that an apparition of light has been given solid form, in contrast with which the mother remains a dark force with the function of giving birth to light. Subsequent comments by Schiele leave the possibility open that as early as puberty the young Egon saw himself as a kind of creature of light, and his mother as no more than an embodiment of natural forces. It was a not uncommon view, one which had been given a pseudo-philosophical legitimacy by Otto Weininger's *Sex and Character* (1903); shortly afterwards it was to become an open conflict between Schiele and his mother.

After some initial hesitation, Schiele's mother had actively supported his wish to attend the Vienna Academy. His guardian Leopold Czihaczek would have preferred to see Egon pursue a "respectable" trade in the railways, and Schiele's mother no doubt had her battles to fight in order to guarantee her son's finances and a roof over his head during his student days. Nevertheless, Schiele could hardly be called a grateful son. Obsessed with the thought of his artistic vocation, he took it for granted that his mother would make sacrifices for him, especially when his father's death left him head of the family. Arthur Roessler, in his memoir of Schiele, conveys the impression that the artist's mother was capable of scarcely credible mental cruelty, and pushed her son to the brink of a deep abyss of desperation. In Roessler's version, which is doubtless subjective and arguably distorted, Schiele complains of his mother in these terms: "I cannot grasp why on earth my mother should treat me so very differently from the way I think I might expect and indeed demand! If it were only someone else! But one's own mother, of all people! It is unutterably sad! And also a terrible burden! – I simply cannot understand that such a thing is possible. It is contrary to nature. One really might suppose that a mother, inside whom the child came into being, grew, lived, breathed, ate and drank, long before it existed in the eyes of others, would subsequently, when it had parted from her and become a living

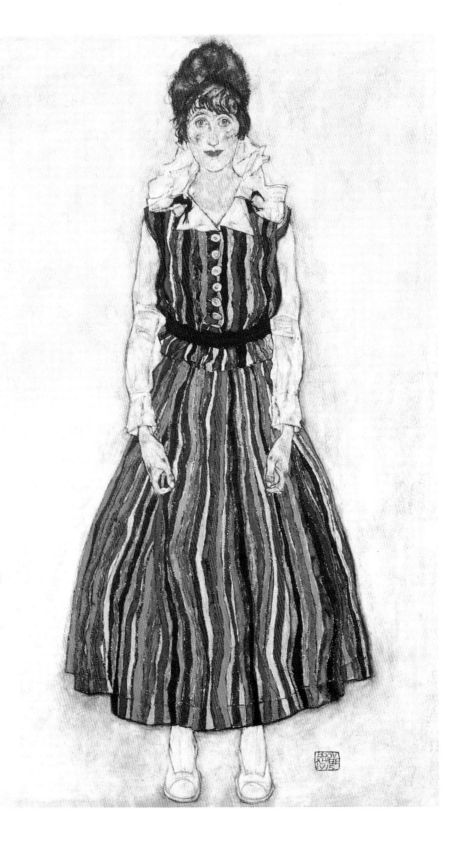

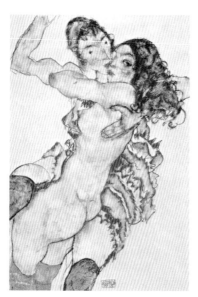

Two Women Embracing, 1915
Zwei Mädchen, einander umarmend
Gouache, watercolour and pencil, 48 x 32.7 cm
Budapest, Szépmüvészeti Múzeum

creature in its own right, still treat her own child as 'a part of herself' and feel it to be such. My mother, whom I resemble in many respects, whose flesh and blood I am, though in spirit we are not alike, unfortunately is not like that. Often she behaves to me as one stranger behaves to another. It hurts me very much."[54]

It is perfectly probable that, after her husband's death, and because of her precarious financial situation (which will have entailed an amount of going without, and surely the occasional humiliation or indignity), Schiele's mother expected greater support or at least a little more restraint from her son. And from her point of view it is wholly understandable that she was none too enthusiastic at Schiele's prospects as an artist – especially since those prospects involved a lifestyle which must have seemed irresponsible and reckless to her. Yet Schiele demanded an almost unconditional willingness to make sacrifices and subordination to his own will; and this made conflict inevitable. Whatever our moral view of this conflict may be, it constituted a challenge which Schiele met in a highly idiosyncratic fashion in his mother pictures. One result was a series of mother pictures Schiele planned in 1910/11, the mere titles of which are alarming. The first painting (in 1910) was *Dead Mother* (p. 70), which was to have been followed by *Birth of Genius, Fräulein Mother* and *Stepmother.* According to Roessler, only *Birth of Genius* (also known as *Dead Mother II,* 1911) was actually painted.

Considered purely in terms of their subject, the *Dead Mother* paintings continue a symbolist tradition which closely linked motherhood and the fear of death. Among the symbolists, however, as the example of Max Klinger's cycle *Of Death II* (1885–98) indicates, the issue was mainly treated in touching, sentimental style. Compared with that, Schiele's *Dead Mother* is a despairing treatment of the theme. As Eva di Stefano has shown, misogyny and a mother complex are alike expressed in it: "The earth-black colours of night dominate the picture. The child, admittedly still alive but marked out by destiny, trapped in the lifeless mother, radiates starry brightness by way of contrast, and the mother's body looks like a transcendent globe."[55] The fact that Schiele's treatment of the subject of mothers was as much an artist's cry of accusation as a positive process of coming to terms with conflict is proved by the very titles of the planned series. In the years that followed, through to 1915, Schiele worked on a number of variations of the theme of mother and child, which suggests that the matter retained a bitter taste for him. In 1911, for instance, it appeared in altogether pessimistic character in the painting *Pregnant Woman and Death* (p. 72). In the 1914 paintings *Blind Mother* and *Young Mother* (also known as *Blind Mother II*) Schiele adds to the preoccupation with unhappy motherhood: the ambivalent image of blindness alludes to the blind (that is: non-existent) love Schiele detected in his mother's attitude towards him, and which was also undoubtedly the true subject of *Stepmother* in the 1910/11 series. This interpretation is strongly supported by a letter Schiele wrote to his mother: "My dear mother! The fact that my requests to you concerning an orderly life have been ignored, and that my well-meant intentions to open up for you a new, true life free of moral precept has gone unseen, has not only dis-

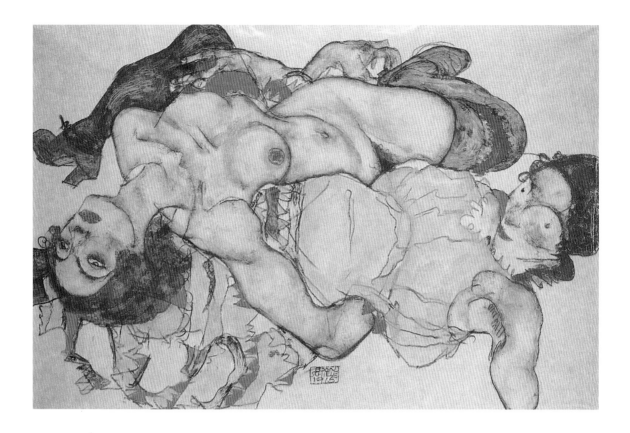

turbed me greatly but has also made me consider applying my goodwill,
which is masculine and filled with leadership and a capacity for life, else-
where, that is, to other receptive persons, things or ventures . . . You are
at an age when I believe people need to see the world with pure pleasure,
unbridled, unrestrained, and want to see the fruits that have been pro-
duced with joy, and to enjoy their own innate will, which has its own in-
dependent roots. – This is the great separation. Without doubt I shall be
the greatest, finest, costliest, purest and most valuable fruit – in me,
thanks to my independent will, all that is beautiful and noble is united; –
for the simple reason that I am a man – I shall be the fruit which, once it
has rotted, leaves an infinite number of living creatures behind it; how
great, then, must your joy be – to have given birth to me?"[56]

The letter makes a number of patriarchal demands concerning the fam-
ily, and damningly judges that sister Melanie "has turned out badly" in
terms of her character. It could hardly fail to hit hard. To the accompani-
ment of bitter complaints that he was neglecting his father's grave,
Schiele's mother laid her curse upon her son that same year: "How much
money do you squander . . . You have time for everything and everyone
under the sun . . . except for your poor mother! God forgive you, but I
cannot . . . Whoever it is that has perverted your way of thinking . . . I
curse, and a mother's curse stays. . ."[57]

Schiele's response to his mother's curse can only be read as a classic

Two Women, 1915
Zwei Mädchen, in verschränkter Stellung liegend
Gouache and pencil, 32.8 x 49.7 cm
Vienna, Graphische Sammlung Albertina

PAGES 66/67:
The Embrace, 1917
Umarmung (Liebespaar II)
Oil on canvas, 100 x 170.2 cm
Vienna, Österreichische Galerie

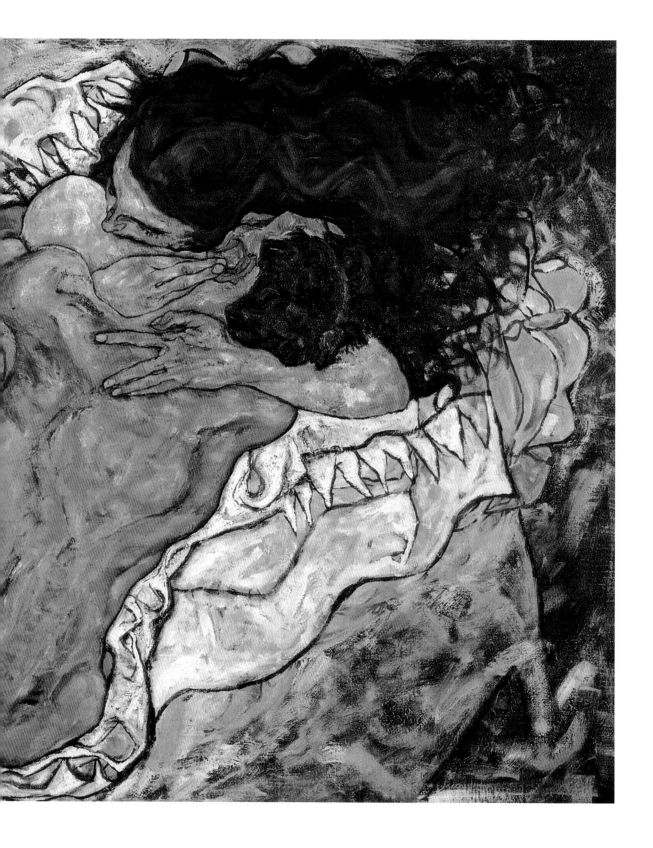

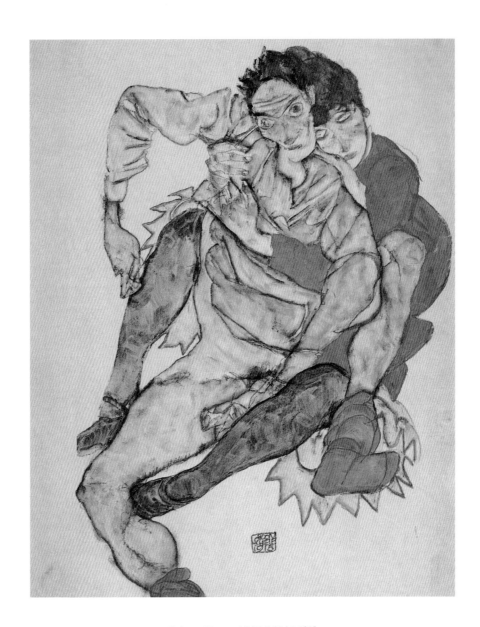

Embrace (Egon and Edith Schiele), 1915
Sitzendes Paar (Egon und Edith Schiele)
Gouache and pencil, 52.5 x 41.2 cm
Vienna, Graphische Sammlung Albertina

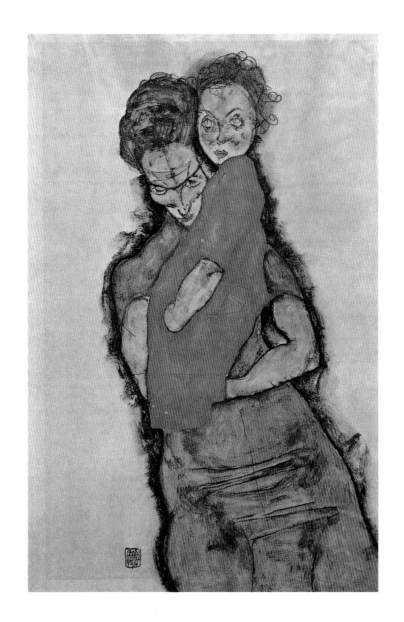

Mother and Child, 1914
Mutter mit Kind
Gouache and pencil, 48.1 x 31.9 cm
Private collection

Dead Mother, 1910
Tote Mutter
Oil and pencil on wooden panel, 32.4 x 25.8 cm
Private collection

example of wounded narcissism, and he seems only to be pretending to understand and attempt a compromise: "Dear mother! I see it all, I'd like to, believe me, you do me an injustice . . . I want to enjoy the pleasure I take in the world, that is why I am creative, and woe to the one robs me of it. – Got it from nowhere, and nobody helped me, I have only myself to thank for my existence."[58] This last sentence above all shows that by this time Schiele was confirmed in his identity as an artist who "created himself", as it were; and any family claims would be seen not merely as burdensome but as a deeply hurtful limit set on his artistic calling. He appears to have seen that calling as a male-cum-intellectual principle, to which the female-natural must be subordinate. Schiele's insistence on male dominance and leadership affected relations with his favourite sister Gerti, for instance; when his painter friend Anton Peschka got Gerti pregnant, Schiele made her wait till she came of age before she married him.

And Schiele's behaviour in separating from his lover Wally Neuzil (p. 62), if not dominantly male, was at the very least singularly unfeeling. He left her in order to marry Edith Harms (p. 63). Since early 1914 Schiele had been trying to get to know Edith and Adele Harms, two young, pretty, middle-class women who lived across the street. He would strike odd poses at his window, or howl "like an Indian"; and, having attracted their attention, invited them on excursions and walks. In order to demonstrate to their sternly moral mother that his intentions were honourable, Schiele took the unsuspecting Wally along on these outings. But in February 1915 a harmless flirtation with Edith Harms became a stronger attraction. And in a letter to Roessler of 16 February he wrote: "I plan to marry – most advantageously, perhaps not Wally."[59]

Schiele and Wally Neuzil had lived together for four years. She was his preferred model in most of his erotic drawings and also appeared in a number of important paintings. She had seen through being hounded out of Krumau, she had stood by him throughout the Neulengbach affair, and now he announced that he would be marrying another woman. Roessler recalled that Schiele asked Wally to join him in his local in Hietzingen, and silently handed her a letter in which he undertook to "spend several weeks every summer on holiday together!!!"[60] Needless to say, this was an offer Wally felt well able to refuse; in any case, she pointed out, Edith would never accept such an odd *ménage à trois* either. Edith does appear to have been quite jealous initially, and she demanded a definite decision. After the separation, Wally volunteered for the Red Cross and died of scarlet fever in Dalmatia in 1917. She never saw Schiele again.

Schiele and Edith married hastily on 17 June 1915, a few days before he was conscripted to Prague. Schiele himself said not a word about the separation from Wally and his decision to marry Edith, but a wish for a settled, steady life seems to have been instrumental. Certain works dating from 1914/15 nonetheless suggest that he was irresolute for a lengthy spell, and that the utopian dream of an untroubled existence with both women tended to displace the thought of single, exclusive commitment. He did several drawings showing two young women locked in an

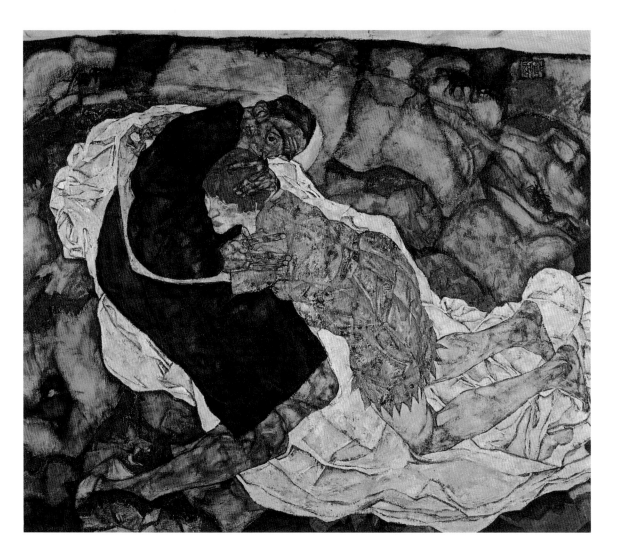

Death and the Maiden, 1915/16
Tod und Mädchen
Oil on canvas, 150 x 180 cm
Vienna, Österreichische Galerie

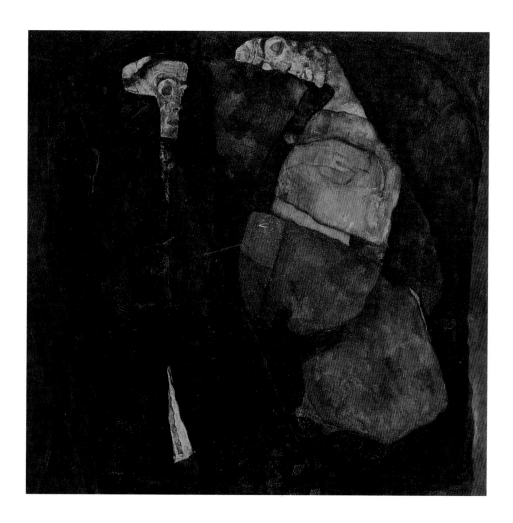

Pregnant Woman and Death, 1911
Schwangere und Tod
Oil on canvas, 100 x 100 cm
Prague, Národní Gallery

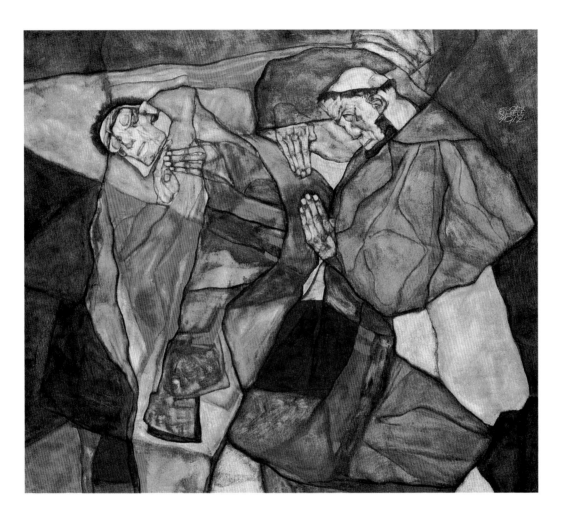

Agony, 1912
Agonie
Oil on canvas, 70 x 80 cm
Munich, Bayerische Staatsgemäldesammlungen,
Neue Pinakothek

Mother and Child (Madonna), 1908
Mutter und Kind (Madonna)
Red chalk, charcoal and white chalk,
60 x 43.5 cm
Vienna, Niederösterreichisches Landesmuseum

erotic embrace (pp. 64 and 65). As if to avoid being too specific about the girl's identity, one of the faces frequently appears as just a few lines, with dots for eyes. Despite an affinity with Amedeo Modigliani's women, the effect is distinctly puppet-like. But just once, in his great painting *Death and the Maiden* (1915; p. 71), Schiele expressed a naked grief at the loss of Wally. *Death and the Maiden* shows a despairing embrace in which all the finality and hopelessness of a love are expressed. The ground is a patchy rust-colour with greenish zones, and across it lies a crumpled sheet the white of which is also suggestive of a shroud, although the decorative quality of the overall composition tends to mitigate the impact of this association. Typically for Schiele, the two reclining figures seem somehow in suspension on the canvas. The man, clad in a dark robe, is recognisable as Schiele himself, while the woman clinging to him resembles Wally. Behind the man's back, the woman's hands have almost completely unclasped; her head still lies on his breast; his left hand still rests tenderly upon her, even as his right seems about to push her away. This gestural tension of intimacy and remoteness is summed up in the man's face, in the fixed, unseeing gaze of his eye from an abnormally large socket, a gaze that includes horror and knowledge of the inevitability of what is to come.

In this painting, Schiele exorcised his loss through art and came to terms with the pain that made marriage to Edith possible. But the marriage, and the acceptance of middle-class normality which it necessitated, also wrought a change in Schiele's approach to the subject of motherhood. It was no longer a matter of his own childhood, no longer a question of personal experience he felt to have been tragic. *Mother and Two Children III* (p. 77), begun in 1915 and finished in 1917, achieves a new tone which is free of conflict and even playful. The longing for love and security which Schiele could only express symbolically through lack in his earlier mother pictures has now been superseded by hope for a family of his own. The sad undertone is still present and is reflected in the faces, but it is counterpointed in the folksy, colourful gaiety of the children's clothing and in the warm, lively orange of the blanket that cloaks the children protectively.

Schiele dealt one more time with the subject of motherhood and new life in *The Family* (p. 76), painted in 1918. It was his last important painting, and documents both his situation in life at that time and his evolution as an artist. With an unaccustomed realism in his rendering of spatial circumstances, Schiele shows a naked man seated on a sofa or bed; it is a self-portrait. In front of him squats a naked young woman with a young child between her legs. The bodies of the two adults and the bright head of the infant, who is wrapped in a blanket, stand out against the dark and economically nuanced background, which (in contrast to earlier paintings) is not subdivided into decorative zones of colour. Now colour is a means of defining subjects, as the bodies of the two naked adults plainly show. Of course the colour is as amply used as ever: white, yellow, red, through to a dark brownish black. But it no longer follows a prescribed linear contour, providing instead an account of three-dimensionality, creating a sense of physical volume and presence. It is

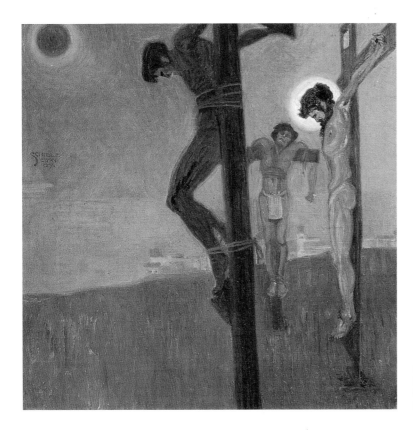

Crucifixion, 1907
Kreuzigung
Oil on canvas, 42 x 42 cm
Private collection

no longer shockingly expressive, but palpable and vitalizing. The man's left hand is sheer paint, without closer definition, and conveys a strong sense of the "painterly" dimension of this work in particular and of Schiele's last two years of life in general.

In a certain sense, this transition to a more realistic and less aggressively overstated visual idiom is matched by the statement the painting makes. It is not out to convey relaxation or even serenity, but it does lack Schiele's earlier shrillness and expressive exaggeration; now he is presenting quiet, passing feelings, and extreme emotionalism has given way to melancholy. It is not only the man and woman's gaze that is melancholy (the man's raised eyebrows seem to imply that he expects no answer). The entire scene is one of melancholy: on the one hand, as the composition moves from man to woman to child it becomes more rounded and more sheltering, but on the other hand this unity is shattered by the discrepancies in the directions in which the three figures are looking. It is as if Schiele, hopeful and confident of a family though he surely was, had an intuitive knowledge that that happiness was not to be his. On 28 October 1918 his wife Edith died of influenza. She was six months pregnant, a fact that Schiele did not see fit to tell his mother till he wrote to her the day before with word of his wife's illness.

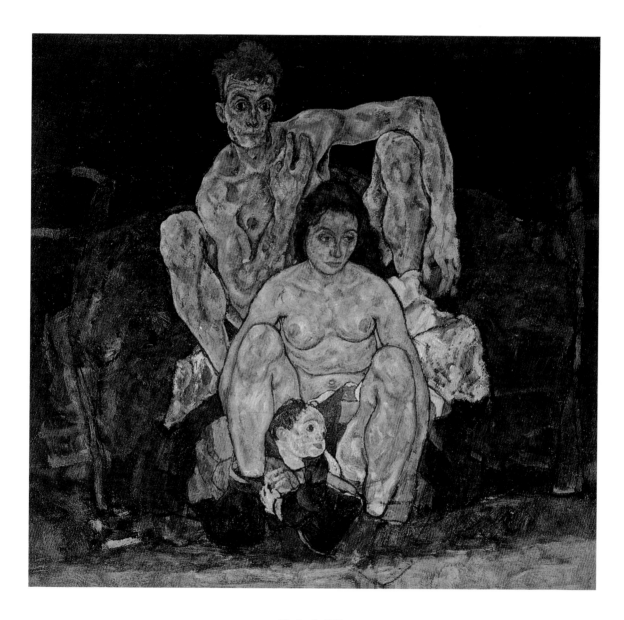

The Family, 1918
Die Familie
Oil on canvas, 152.5 x 162.5 cm
Vienna, Österreichische Galerie

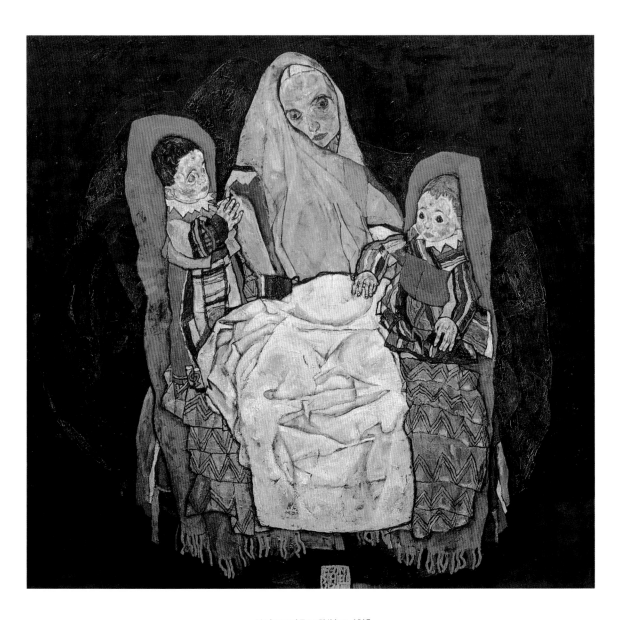

Mother and Two Children, 1917
Mutter mit zwei Kindern III
Oil on canvas, 150 x 158.7 cm
Vienna, Österreichische Galerie

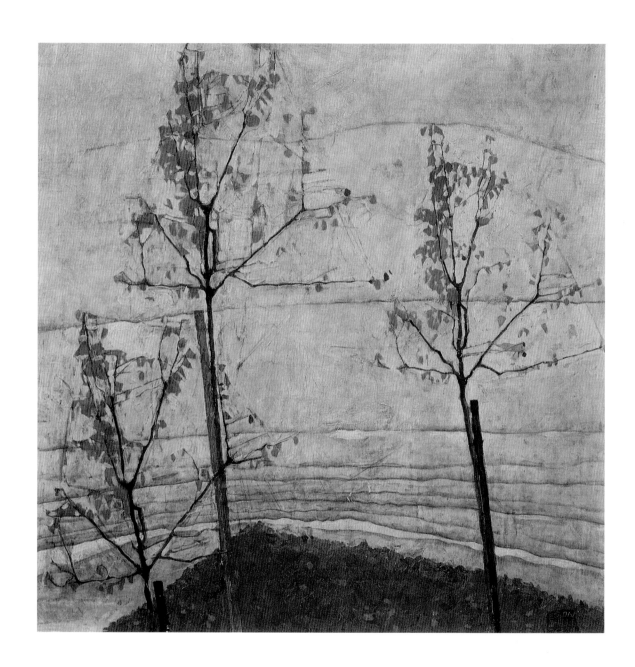

Landscapes of the Soul

A few days after he married Edith Harms, Schiele left for Prague to do
his military service. Edith accompanied him and initially put up at the
Hotel Paris. At least her presence made the understandably grim life of
the barracks intermittently endurable for Schiele. Not that his wartime
life was one of the worst. After basic training he was not sent to the
front, but mostly had clerical duties and was stationed near Vienna,
which meant that he could live in his own four walls. It took him till
1917, and an infinite number of attempts and official applications, till he
was transferred to Vienna, though. Until early 1916 he was a p.o.w. es-
cort at Atzgersdorf, south of Vienna, and in the spring of that year he
was posted to Mühling in Lower Austria as a clerk in a prison camp for
Russian officers. From March to November 1916 he kept a detailed war
diary; much of the content, alas, is trivial, apart from one or two lively
accounts of his surroundings and stray remarks of a political nature, but
some of the material is interesting enough to quote. On 12 March 1916,
for example, after talking to Russian prisoners of war, he noted: "Their
longing for perpetual peace was as great as mine, and the concept of a
Europe consisting of united states appealed to them."[61] On another occa-
sion, on 4 April, he wrote: "To me personally, where I live is a matter of
indifference, that is, which nation I belong to, or rather, which nation I
live in. – At all events I tend far more to the other side, that is, our
enemies – their countries are far more interesting than ours – there they
have real freedom – and more thinkers than we have. But what is one to
say about the war now – every hour that it continues is a great pity."[62]

Clear as these remarks are, it remains true that Schiele only rarely said
anything concerning everyday politics or the course of the war. And yet
he was not an apolitical man. This is shown by the mere fact that he
worked for Franz Pfemfert (who was a political activist) and his maga-
zine *Die Aktion*, which Albert Ehrenstein, Else Lasker-Schüler, Heinrich
Mann, Franz Werfel and others wrote for. It is also shown by the fact
that Schiele, unlike numerous fellow-artists and writers (such as Ko-
koschka or Max Liebermann), was unenthusiastic about the war from the
start. Nationhood and ideas of race and *Volk* were alien to him, even re-
pugnant. To Schiele, war merely represented the "wretched deaths of
hundreds of thousands of people". His spiritual interests, though at times
they led him into the mists of mysticism, were inseparable from his
quest for an individual identity, and with a profound contempt for all

Young Fruit Tree, 1912
Junger Obstbaum
Gouache, watercolour and pencil, 46.4 x 29.7 cm
Vienna, Graphische Sammlung Albertina

Autumn Trees, 1911
Herbstbäume
Oil on canvas, 79.5 x 80 cm
Private collection

Withered Sunflower, 1912
Welke Sonnenblume
Gouache and pencil, 45 x 30 cm
Private collection

OPPOSITE PAGE:
Sunflower II, 1909
Sonnenblume II
Oil on canvas, 150 x 29.8 cm
Vienna, Historisches Museum der Stadt Wien

forms of collectivism, for "the eternal wearers of uniforms . . . the soldiers, officials, teachers, all those without a necessary existence, the manual workers, the clerics, those who want things right away, the nationalists, patriots, arithmeticians, people of status, ciphers."[63] Thus Schiele in 1911, in polemical yet poetic vein, to Arthur Roessler. And in November 1914, only a few months after the outbreak of the First World War on 4 August, he wrote to his sister: "What lay before 1914 was part of another world. . ."[64]

It sends a pleasant shiver down many of our spines, to think that artists have second sight, have intuitive foreknowledge of terrible things that lie ahead, and can express those things in a form that we ordinary mortals only recognise after the event. But of course, if we bear Schiele's life in mind, many of his ideas and works that seem rifted with premonitory pathos appear in a different light. They are better explained as the result of childhood experiences (such as the death of his father) which pursued him well into later life in his dreams.[65] Consistently enough, one of Schiele the poet's key statements was: "All things are living dead."[66] This slogan governed his basic existential mood in the pre-war years, and it was only from 1915 on that Schiele's work lost its dark, tormented quality – as if the bloody reality of war had overtaken his worst visions, and the artist's imaginative powers were now altogether preoccupied with the possibility of restoring wholeness to the world. Schiele's landscapes and townscapes are the best place to see this process at work.

In his work on landscape and the natural world, Schiele (as was generally the case throughout his artistic development) turned away from mimetic representation, after his first few attempts, and, via Klimtian decorativeness, arrived at a method in which plants and other subjects were increasingly subjected to anthropomorphic treatment and acquired a gestalt quality. In a 1913 letter to collector Franz Hauer, Schiele described his progress to a vision of nature that depended not only on the final painted work but also on the drawn sketches: "I also do studies, but I find, and know, that copying from nature is meaningless to me, because I paint better pictures from memory, as a vision of the landscape – now, I mainly observe the physical movement of mountains, water, trees and flowers. Everywhere one is reminded of similar movements made by human bodies, similar stirrings of pleasure and pain in plants. Painting is not enough for me; I am aware that one can use colours to establish qualities. – When one sees a tree autumnal in summer, it is an intense experience that involves one's whole heart and being; and I should like to paint that melancholy."[67] This approach to nature can already be seen in the 1909 *Sunflower II* (p. 81). In a style comparable to the figure paintings of that period, the tall, delicate flower no longer appears wrapped in a decorative cocoon of ornamental lines; rather, it seems isolated, exposed. The way the sunflower's large leaves are drooping recalls human gestures, and Schiele's comment on the pleasure and pain in plants becomes accessible. The vertical format, colouring and quasi-human gestural repertoire make of the sunflower an image of feelings elegiac. The poet Georg Trakl, who shared Schiele's near-identification with the martyred St. Sebastian (p. 93), came close to this kind of apprehension of na-

ture in "The Sunflowers", a late poem: "You golden sunflowers, / Feelingly bowed to die, / You humble sisters / In such silence / Ends Helian's year / Of mountainous cool. And the kisses / Make pale his drunken brow / Amidst those golden / Flowers of melancholy / The spirit is ruled / By silent darkness."[68]

There are paintings which prove the point even more forcefully, in which a single tree or group of trees appear as the main subjects and signifiers (p. 78). A leafless tree on an ice-grey ground, bizarre branches angled to suggest movement reminiscent of ecstatic movements in expressive dance forms: though the subject is simple to the point of poverty, Schiele manages to make it a metaphor of sadness and transience.[69] At this period in Schiele's life, the tree in autumn is not only an image of dying nature but also symbolic of a spiritual condition. If we compare one of these autumn trees with Giovanni Segantini's 1894 painting *The Wicked Mothers* (p. 84), which was bought in 1902 by the Austrian state following a highly successful Segantini exhibition in Vienna, we might venture an interpretation that associates this work with Schiele's mother pictures. The subject of the wicked mothers was prompted by a passage in an Indian poem which Segantini had already drawn upon in 1891 for his painting *The Hell of the Lascivious.* It deals with the infinite spaces of nirvana, and the punishment and redemption of women who have refused motherhood. After death, these "wicked mothers" are condemned to wander forever in deserted snowy regions. "For Segantini, who lost his own mother when he was five and spent a joyless childhood in his stepmother's house, the intimate link with the mother was a central subject. In *The Wicked Mothers* a woman is in suspension in the foreground, her long hair caught in the dry branches of a tree. As if whipped by the wind, the woman's body is bending, and at her bare breast she has a dead babe." For Segantini, this woman is "a terrible woman, a mother whose denial of motherly love can go as far as to kill her own child. The tree and its tangle of branches seen against the cold sky . . . seems cold and dead although it is a natural object." The woman is "a symbol of perverted motherhood."[70] Of course Schiele's autumn trees were not direct imitations of Segantini's picture. But still, the affinity of shape and colour is so great that we may well suppose not only that he was familiar with the painting but also that he was projecting a similar significance into his tree-soul pictures. And we should remember that the paintings were done at about the same time as his gloomy mother pictures. This would imply that the dying tree is a coded image of a highly subjective feeling that had an intimate part to play in Schiele's psychological state.

It is not until later landscape paintings such as the 1917 *Four Trees* (pp. 82/83) that Schiele's cold palette becomes warmer. The dead ground has become a landscape glowing with colour, and its mood is not one of violent emotional impact but rather of gentle feeling. The painting has not shed its visionary traits, though. This is not a real landscape but a constructed one dominated by horizontal and vertical structures, a landscape so ruled by symmetry that deviations appear significant. The one almost leafless tree that stands between two others which are still in full leaf recalls the "melancholy" aroused by "a tree autumnal in summer".

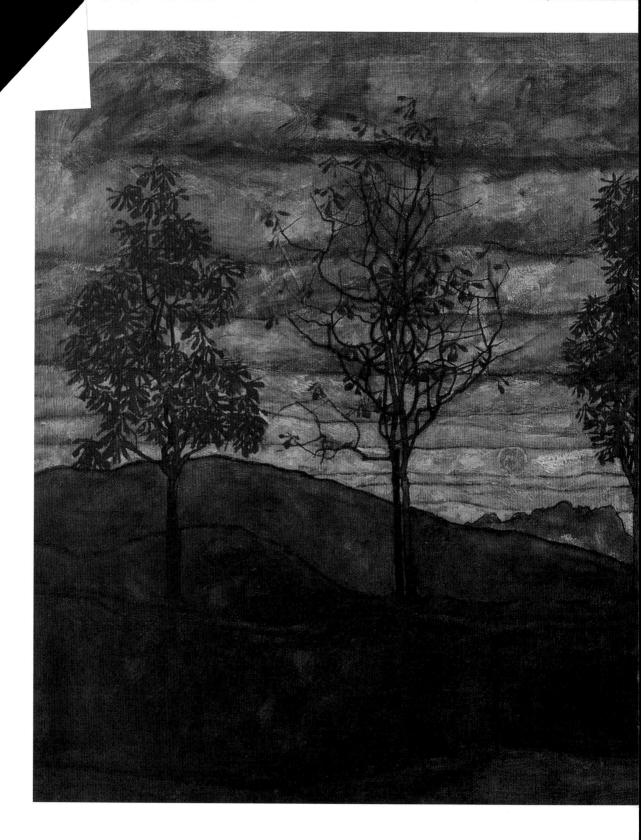

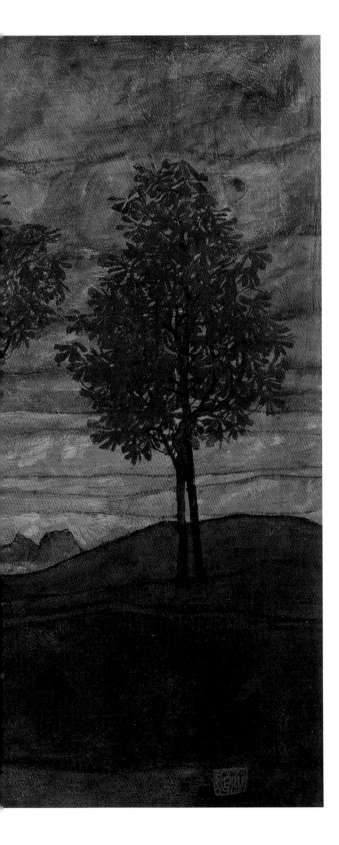

Four Trees, 1917
Vier Bäume
Oil on canvas, 110.5 x 141 cm
Vienna, Österreichische Galerie

This landscape vision is Schiele's continuation of early poems in which
he expressed cosmic sensation in words which have synaesthetic colour-
ings more like the writing of Rimbaud than that of Trakl. Schiele's poem
"Sun" may serve as an example: "Taste redness, smell lulling white
winds, / look at it in the universe: sun. / Gaze at stars yellow and glitter-
ing / till you feel good and have to shut out the blinking. / Brainworlds
sparkle in your caves. / Let your feeling fingers tremble, / touch the ele-
ment, / you who must seek yourself, thirsty and tottering, / leaping you
sit, running you lie, / lying you dream, dreaming you wake. / Fevers eat
up hunger and thirst and aversion, / blood passes through. // Father, who
art there, look at me, / envelop me, / give unto me! / Near-to world run
up and down in a rage. / Now stretch out your noble bones, / lend me
your tender ear, / fine pale blue eyes. / That, Father, once was – / before
You am I!"[71]

Schiele's townscapes underwent a transformation comparable to the
change in his pictures of nature. But in this case the visionary element
ebbed away more strikingly from about 1914 on, and towards the end of
his life (despite or perhaps because of the perfection of his artistic tech-
nique) was replaced by an almost idyllic way of seeing. Schiele's love of
small towns and villages played a vital part in this development. In con-
tradistinction to the contemporary art of Ludwig Meidner, the Futurists,
or the French Post-Impressionists, for whom the city, traffic, and move-
ment were crucial, Schiele in a sense always remained the boy from the
provinces. As a "Sketch for a Self-Portrait" written in 1911 for Roessler
indicates, Schiele took up a defensive position towards the city from the
outset. (Nor did he develop any great love of the city when the war tem-
porarily required him to do without Vienna and thus without the am-
bience he so needed as an artist.) But he was certainly fascinated by the
city's wealth of phenomena, and by its sheer size. Time and again, how-
ever, he fled to the easily-surveyed realm of the small town, his own
home environment. "I went to towns that seemed endless and dead, and
felt sorry for myself,"[72] wrote Schiele in the "Self-Portrait"; so it comes
as no surprise that after his youthful phase (views of Klosterneuburg and
such places, done in a fairly traditional style) there are two important

Autumn Tree with Fuchsias, 1909
Herbstbaum mit Fuchsien
Oil on canvas, 88.5 x 88.5 cm
Darmstadt, Hessisches Landesmuseum

townscapes among those he did after 1910 that carry the title *Dead Town VI* (p. 90). In them, Schiele was uniting his personal experience with a subject that had been aesthetically defined before the turn of the century. In 1892 the Belgian symbolist Georges Rodenbach had published his novel *Bruges-la-morte* (i.e. *Dead Bruges*). A German translation was soon available, and the composer Erich Wolfgang Korngold even adapted it as an opera, *The Dead Town.* In 1898 Gabriele D'Annunzio's prose tragedy *La città morta* was premiered in Paris, with Sarah Bernhardt in the lead. Generally speaking, old cities such as Bruges, Toledo and Venice, cities which had flourished in the middle ages or Renaissance, were considered to bear witness (in brick and mortar) to a biologically-coloured view of history which distinguished epochs of ripening, full flowering, and decay. The predilection for cities either dying or locked in a picturesque Sleeping Beauty slumber perfectly expressed the love of decay which was so characteristic of the decadent *fin de siècle.* Melancholy and decay were popular. The painful experience of transience was thrilling. "Bruges is a witch's mirror which, five hundred years after the city was at its greatest, still conveys an image of the indescribable beauty of wealthy mediaeval cities. But one scarcely notices this. For all these buildings, once so defiant and proud, seem to be slumbering like Sleeping Beauty. Ivy climbs the grey walls. The buildings contrast with the deserted streets and poor people, and one no longer

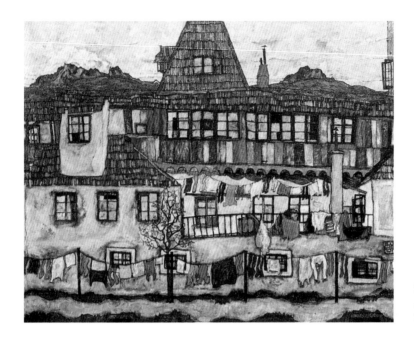

Suburban House with Washing, 1917
Vorstadthaus mit Wäsche
Oil on canvas, 110 x 140.4 cm
Private collection

sees the splendour of yesteryear, only the ills of the present, one does not hear the breathing of a great city, only its death rattle."[73]

Unlike the symbolists, and indeed unlike art critic Richard Muther (just quoted), Schiele was not primarily interested in the age of towns and cities. The sadness in his "black" and "dead" towns has nothing to do with observation and aestheticization of historical decline and decay. Rather, the dead state of his towns reflects his own condition. In a 1910 painting now lost, *Universal Melancholy,* Schiele made this unambiguously clear by combining a self-portrait (with the characteristic gestures suggestive of helplessness) with the presentation of a dead town. The dead or black town is for Schiele the phenomenological epitome of a condition in the human spirit: even if Krumau is the subject, no topographical precision is called for, not even indeed any people. The walls, windows and roofs of the houses have physiognomies all their own, facial eloquence that expresses the lives of those who live there: "Now I see the black town again, / which has always remained the same, / all the back-parlour folk are walking about as they always did, / – the poor people – , / so poor, / the rustle-red autumn leafage smells like them. – / But how good autumn is in this windwinterland!"[74]

In dispensing with precise delineation of a place, or verifiable topography, and in concentrating on the "facial expressions" of the houses and towns, Schiele was ultimately creating visionary parables of anti-urban experience.[75] Human beings cannot live in these towns; they can only be buried there. Albert Paris Gütersloh realised this early on, in an essay written in 1911, and he felt that the effect was a result of Schiele's use of bird's-eye-view perspective: "He calls a town which he looks down on

Facade with Windows, 1914
Hauswand (Fenster)
Oil and gouache, 110 x 140 cm
Vienna, Österreichische Galerie

from above and views foreshortened the dead town. Because every town looks dead seen like that. The hidden meaning of the bird's-eye view has unconsciously been revealed. Taken as an idea, the title is the equal of the picture it defines. In pictures such as the two under discussion (the second is a portrait of the writer Thom), and in the great expanse of the 'Deliria', Schiele has found the way that will take him far from his beginnings, ever closer to himself, till he will paint the terrible guests who suddenly visit the artist's midnight soul just as they are as they enter, and not as they are when, paled by the habit of too lengthy scrutiny, they depart."[76]

Gütersloh, who was himself a writer and painter, knew Schiele well and knew that the meaning of the bird's-eye view lay not in any intention to keep a distance from things in order to achieve an objective overview. He knew that the source of Schiele's inspiration was the inner image or vision. Only if the artist takes a position up above will things become projections of "the terrible guests who suddenly visit the artist's midnight soul". Of course Gütersloh had no way of predicting that the change in Schiele's personal circumstances, his marriage, and the war, would mark a caesura in his visual and conceptual approach, a caesura detectable throughout his artistic oeuvre.

From about mid-decade, Schiele did pictures of towns and houses where the symbolic weight and visionary depth were displaced by other qualities. Thus in *Ruined Mill,* which Schiele painted at Mühling in 1916, we see a heightened interest in the physical actuality of things. The nuances of light and shadow are too closely observed, the rotting and broken wood of the mill is too detailed and carefully coloured, the

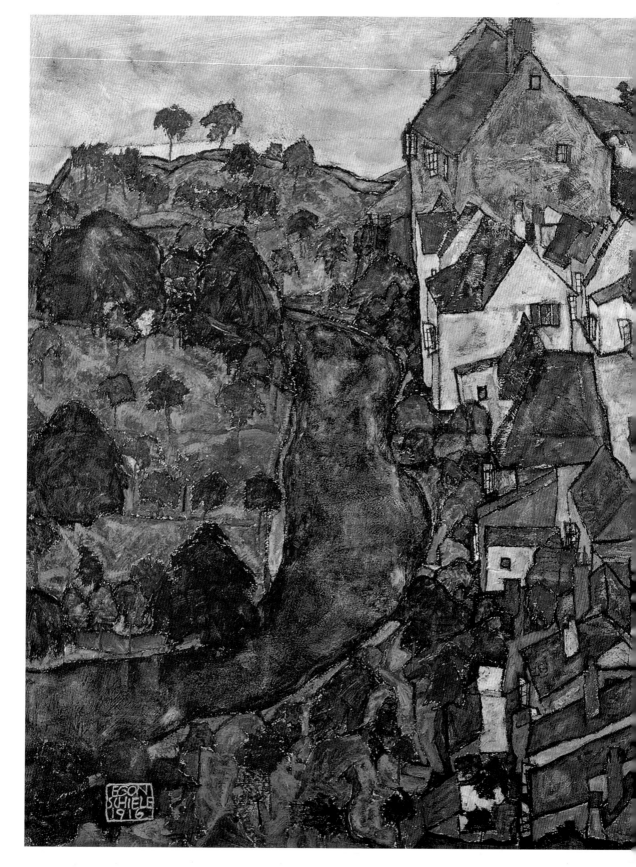

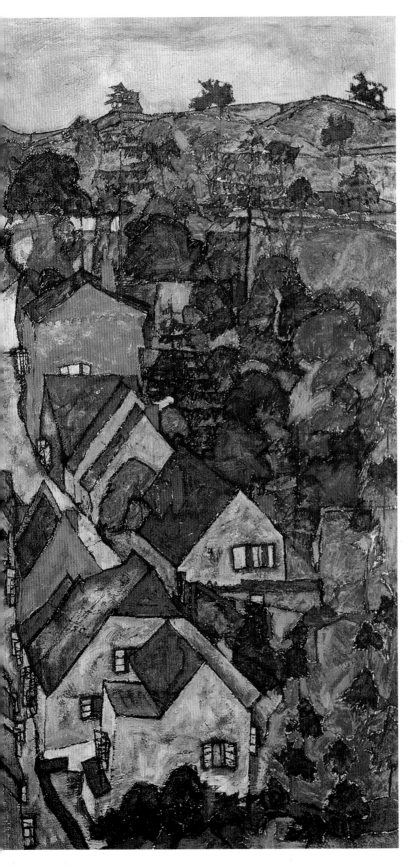

View of Krumau, 1916
Krumauer Landschaft
Oil on canvas, 110 x 140.5 cm
Linz, Neue Galerie der Stadt Linz,
Wolfgang-Gurlitt-Museum

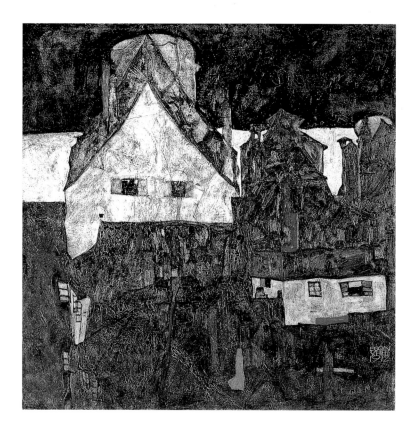

rushing water of the stream (the fraying spray reminiscent of Japanese woodcuts) is too full of life, for there to remain room for the purely visionary. Transience and decay are no longer the products of the soul's expressive sign system, of a gloomy masking process in colour; rather, they are real qualities present in the subject, seen in the thing itself. In other works such as *View of Krumau* (1916; pp. 88/89) or *Suburban House with Washing* (1917; p. 86) Schiele's way of seeing is cosy and home-loving, out to emphasize the picturesque or decorative aspects of his modest subjects. Schiele is in the process of countering his earlier visionary view of landscapes and towns (for which Gütersloh had provided the theoretical legitimation) with an aesthetically mellowed frontal view which he seemingly explained to Leopold Liegler, in conversation, in this way: "Really it was forced upon me in Krumau. There you learn to look at the world from above; and the unusualness of this way of seeing, this frontal view, acquires a painterly and graphic value. . ."[77]

In the pictures of human figures, the frontal view had a destabilizing effect, causing the bodies to totter or hover in suspension, revealing them, exposing them to indiscreet scrutiny. In the townscapes, by contrast, the bird's-eye view initiated a voyage of exploration into an orderly universe of things which had their proper places. The *raison d'être* of this world is not suspension but construction, as seen in the predominance of vertical, horizontal and diagonal lines. It is the specific juxtapo-

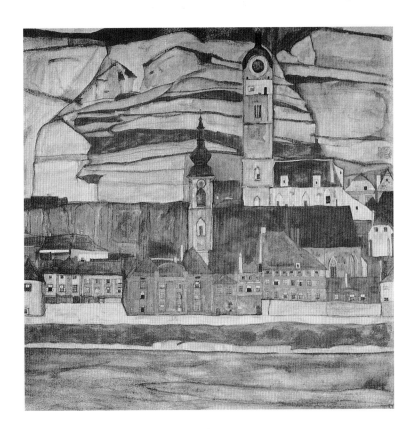

Stein on the Danube, 1913
Stein an der Donau (Große Fassung)
Oil on canvas, 89.8 x 89.6 cm
Private collection

sitions and relations of lines and spaces that produces the painterly and graphic value Schiele referred to. But at the same time these interactions produce a decorative, almost craftsmanly texture in the paintings, and in the drawings an illustrative dimension which, while it certainly explores atmospheric values with great sensitivity, remains largely free of symbolic or formal highlighting.

Viewed in another context, this apparently lightweight handling of content is indicative of (pre-)conscious selection. The colourful, tapestry-like patterning of houses nestling up against each other does not contrast with the landscape; the draughtsmanly arabesques that appear in some corner of an old town do not contrast with the brutal track of a modern road – in other words, the yawning gap between nature and human civilization, between the old and the modern, which van Gogh and some of the Impressionists had already taken as their theme, is never one of Schiele's concerns. In his landscapes and townscapes there is no industry, there are no smoking factory chimneys or other signs of modern technology. In this, once again, Schiele resembled Trakl: for him, the city did not afford a "landscape of the soul". It is as if in his view the city and modern life (like the "bloody horror of the world war") constituted equally fateful products of the "materialist tendencies in our civilization", which he had no intention of reflecting in his art. It was no mere nostalgia, but a perfectly consistent continuation of the *Ver Sacrum* line

Poster for 49th Secession Exhibition, 1918
Lithograph, 63.5 x 48 cm
Vienna, Graphische Sammlung Albertina

Self-Portrait as St. Sebastian
(Poster for Arnot Gallery exhibition), 1914/15
Selbstportrait als heiliger Sebastian
Indian ink and opaque, 67 x 50 cm
Vienna, Historisches Museum der Stadt Wien

of the Vienna Secession, that prompted him to believe in the "remains of a noble civilization", and that these remains could only be preserved with the aid of the arts – if "the progressive cultural disintegration" he detected were to be halted.

Schiele expressed his hopes for aesthetic salvation through the arts in a letter written in 1917 to his brother-in-law Anton Peschka. In the same letter he described his plans for an artists' association and expounded his idealistic conception of it.[78] This ambitious project, called "Kunsthalle", stood no real chance in time of war. And yet, in Schiele's draft of an "appeal", alongside his quasi-religious notions of art there is an unmistakable, pragmatic sense of purpose. When he began his career, art had seemed a vocation and nothing else, the expression of a lonely self; now it had apparently also become an institution and a matter of societal importance. Through the good offices of Leopold Liegler, who had written a lengthy article about him in the periodical *Graphische Künste* in 1916, Schiele had finally been transferred to Vienna in spring 1917, and was thus in a position to exert a direct influence on happenings in the art world. He exhibited at a number of shows, and himself helped organize the "War Exhibition" in Vienna in May 1917. He began to score his first public successes. Dr. Franz Martin Haberditzl, director of the Modern Gallery, bought some drawings, and the following year he went so far as to acquire the large portrait of Edith Schiele. This sale mattered so much to Schiele that he was even willing to paint over Edith's skirt, which had been brightly coloured, at Haberditzl's request. And when book dealer Richard Lányi published a portfolio of collotype reproductions of Schiele drawings and watercolours, the importance of this further recognition was almost as great.

On 6 February 1918 Gustav Klimt died. For the space of a whole generation he had been the presiding mandarin amongst Viennese artists, and to the end had remained a venerated exemplar for Schiele. By this time Schiele's name was becoming widely known too, and he saw himself as Klimt's legitimate successor. At the 49th Vienna Secession Exhibition, where Kokoschka had declined to show, Schiele was hailed as the leader of the Viennese art community. It was he who had organized the exhibition, he who had designed the poster (p. 92), and he whose paintings and drawings made so tremendous an impression that the international press (for instance, the *Neue Zürcher Zeitung*) joined in the accolade. It was his greatest triumph, his finest hour – and Schiele was well aware of his new status. And it was then, of all times, that Edith fell ill and died within a matter of days. Schiele too caught Spanish influenza; and three days after his wife, on 31 October 1918, he followed her to an early grave.

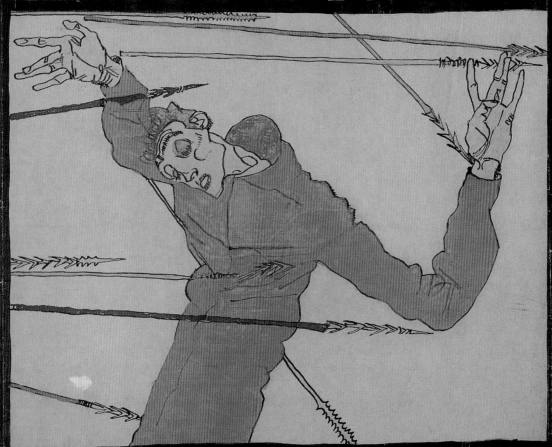

Egon Schiele 1890–1918: A Chronology

1890 Egon Schiele is born on 12 June at Tulln, a small town near Vienna, the third of four children of Adolf Eugen Schiele (1851–1905), a stationmaster on the Austro-Hungarian Imperial Railways, and his wife Marie née Soukoup (1862–1935). His three sisters are Elvira (1883–1893), Melanie (1886–1974) and Gerti (1894–1981).

1896 Primary school in Tulln.

1902 Grammar school in Krems.

1902 Moves to Klosterneuburg. Grammar school there.

1905 Father, pensioned off for mental instability in 1902, dies on 1 January.

Egon Schiele (left) with his parents and sisters Melanie and Elvira, c. 1892

Egon Schiele the Academy student, 1906

Schiele paints a large number of works, including his first self-portraits.

1906 Against the wish of his guardian Leopold Czihaczek he joins Christian Griepenkerl's classes at the Vienna Academy. As at school, Schiele's performance is unremarkable.

1907 Influenced by the style of Klimt and the Vienna Secession.

1908 Exhibits work for the first time in Klosterneuburg.

1909 Exhibits in the second Art Show *Kunstschau* in Vienna. Leaves the Academy and founds the *Neukunstgruppe* (New Art Group) with friends. Meets critic Arthur Roessler and through him collectors Carl Reininghaus and Oskar Reichel.

First New Art Group exhibition at Pisko Gallery.

1910 Evolves his own style. Painting at Krumau with Erwin Osen, an eccentric stage set painter, and produces numerous expressive nudes. First poems. Meets Heinrich Benesch.

1911 Obliged to leave Krumau because he is living with model Wally Neuzil. Finds a new place to live at Neulengbach. Associated with Munich art dealer Hans Goltz. Joins Sema art association in Munich. First publications on Schiele by Albert P. Gütersloh and Arthur Roessler.

1912 Various exhibitions, including Vienna, Munich, Cologne. From 13 April

Egon Schiele: Self-Portrait, 1906

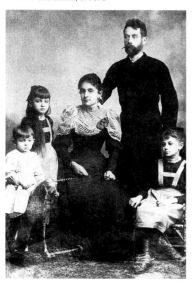

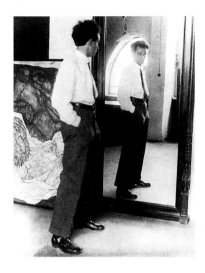

Egon Schiele in front of his studio mirror, 1915

1913 Schiele joins *Bund Österreichischer Künstler* (Federation of Austrian Artists). Exhibits in shows in Budapest, Cologne, Dresden, Munich, Paris and Rome. First work for Franz Pfemfert's Berlin periodical *Die Aktion*.

1914 Schiele meets the Harms sisters. Takes tuition in etching technique. Unsuccessfully competes in the Reininghaus Competition. Exhibits in Rome, Brussels, Paris. A number of photographs are taken of him. August: First World War begins.

1915 Schiele breaks with Wally Neuzil after four years and marries Edith Harms on 17 June. Soldier in Prague, then Vienna. In the next two years he paints very little.

1916 Exhibits widely, including the *Wiener Kunstschau* (Vienna Art Show). *Die Aktion* does a Schiele issue. He is transferred to a clerk's post at Mühling in Lower Austria.

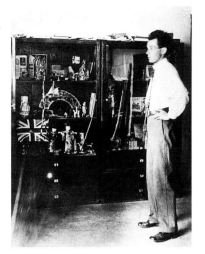

Egon Schiele in his studio, 1915

he is in custody for three weeks at Neulengbach. Erotic drawings confiscated. At the trial in St. Pölten he is sent down for three days in gaol for disseminating immoral drawings. Charge of sexually abusing children is dropped. In prison he does a number of drawings recording his experience of detention. Moves into new studio in Vienna.

1917 Transferred back to Vienna. Travels. Plans an artists' association. Bookseller Richard Lányi publishes a portfolio of 12 collotype reproductions of Schiele drawings. Exhibits in shows of Austrian art.

1918 6 February; death of Gustav Klimt. Schiele transferred to Army Mu-

seum in Vienna. Scores a great success at the Vienna Secession Exhibition in March, for which Schiele also designs the poster (p. 92). Most of Schiele's fifty works in the show are sold. Exhibits in Zürich, Prague and Dresden. 28 October: death of Edith. Shortly after, on 31 October, Egon Schiele dies of Spanish influenza.

Egon Schiele in his studio, 1915

Egon Schiele, 1914

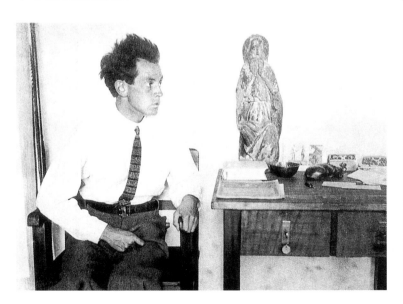

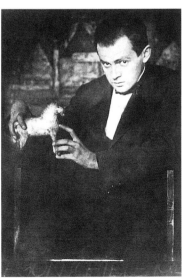

Notes

1 Quoted from C. M. Nebehay, Egon Schiele 1890–1918. Leben-Briefe-Gedichte. Salzburg/Vienna 1979, p. 231 (No. 412).

2 L. B. Alberti, Kleinere kunsttheoretische Schriften, H. Janitschek (ed.), Vienna 1877 (Reprint Osnabrück 1970) pp. 90f.

3 F. Nietzsche, Nachgelassene Fragmente 1887–1889 (critical annotated edition [KSA], G. Colli/M. Montinari, eds, vol. 13), Munich 1988, pp. 517f.

4 F. Nietzsche, Also sprach Zarathustra I–IV(Thus Spake Zarathustra) (critical annotated edition [KSA] 4, op. cit.), p. 40.

5 Nebehay, (1979), p. 184 (No. 264).

6 Ibid.

7 M. Arnold, Egon Schiele. Leben und Werk, Stuttgart/Zurich 1984, p. 53.

8 An example from the literature at the turn of the century can be found in L. v. Andrian's esoteric tale "Der Garten der Erkenntnis" (The Garden of Knowledge), written in 1895, in which Erwin, the main character, meets his doppelgänger as a messenger of death. Cf. J. M. Fischer, Fin de siècle. Kommentar zu einer Epoche, Munich 1978, p. 144ff.

9 Quoted from E. Fischer/W. Haefs (eds), Hirnwelten funkeln. Literatur des Expressionismus in Wien, Salzburg 1988, p. 366.

10 Ibid.

11 P. Hatvani, 'Egon Schiele' in Der Friede 2 (1918/19), 44, p. 432.

12 H. v. Hofmannsthal, Erzählungen, erfundene Gespräche und Briefe. Reisen (Collected works in 10 volumes, B. Schoeller (ed.), Frankfurt/M., 1979, p. 466).

13 A. Roessler, Erinnerungen an Egon Schiele, Vienna 1948, p. 32f.

14 H. Benesch, Mein Weg mit Egon Schiele, New York 1965, p. 13.

15 C. M. Nebehay, Egon Schiele. Leben und Werk, Salzburg/Vienna 1980, p. 28.

16 Roessler (1948), pp. 25f. – Roessler's reminiscences have to be taken with a grain of salt as he not only corrected Schiele's language but also noticeably portrayed some of the details of Schiele's life in a more favourable light.

17 Cf. C. M. Nebehay, Egon Schiele. Von der Skizze zum Bild. Die Skizzenbücher, Vienna 1989, especially pp. 120ff.

18 W. Hofmann, 'Das Fleisch erkennen' in A. Pfabigan (ed.), Ornament und Askese im Zeitgeist des Wien der Jahrhundertwende, Vienna 1985, p. 122.

19 W. Kandinsky, Punkt und Linie zu Fläche, Bern-Bümpliz (3) 1955, p. 75.

20 Nebehay (1979), p. 215 (No. 320).

21 Nebehay (1979), p. 112 (No. 93).

22 Seligmann, quoted from W. J. Schweiger, Der junge Kokoschka. Leben und Werk 1904–1914, Vienna 1983, p. 67f.

23 L. Hevesi, Altkunst–Neukunst. Wien 1894–1908, Vienna 1909 (new ed. and intr. by O. Breicha, Klagenfurt 1986), p. 313.

24 Nebehay (1980), p. 63.

25 Roessler (1948), p. 47ff. On the question of their personal encounter, see Nebehay (1980), p. 62.

26 Benesch (1965), p. 25f.

27 G. Fliedl, Gustav Klimt 1862–1918. The World in Female Form, Cologne 1989, p. 127.

28 See for example Benesch (1965), p. 29.

29 A. Roessler (ed.), Briefe und Prosa von Egon Schiele, Vienna 1921, pp. 97f.

30 Nebehay (1979), p. 182 (No. 251).

31 Benesch (1965), pp. 29f.

32 Nebehay (1979), pp. 191ff.

33 Nebehay (1979), p. 262 (No. 527).

34 Cf. the brillant chapter by P. Werkner in Physis und Psyche. Der österreichische Frühexpressionismus, Vienna/Munich 1986, pp. 168ff.

35 Roessler (1948), p. 36.

36 M. v. Boehn, Der Tanz, Berlin 1925, pp. 120f.

37 L. Hevesi, Acht Jahre Secession (March 1897–June 1905). Kritik-Polemik-Chronik, Vienna 1906 (new ed. and intr. by O. Breicha, Klagenfurt, undated), p. 369.

38 Hevesi (1909), p. 282.

39 Nebehay (1979), p. 270 (No. 570).

40 Quoted from T. Medicus, Das Theater der Nervosität. Freud, Charcot, Sarah Bernhardt und die Salpêtrière in Freibeuter 41 (1989), pp. 99f.

41 Hevesi (1906), pp. 343ff.

42 J.-M. Charcot/P. Richer, Die Besessenen in der Kunst, with an afterword by M. Schneider (ed.), Göttingen 1988, p. 138. Cf. also p. 144.

43 Ibid., p. 138.

44 M. Nordau, Entartung, 2 vols., Berlin 1892/93.

45 A. Roessler, Hagebund critique in the Arbeiter-Zeitung, 14. 5. 1912, quoted from Nebehay (1979), p. 221 (No. 351).

46 Nebehay (1979), p. 233 (No. 427).

47 F. Whitford, Egon Schiele, London 1981, p. 142.

48 Nebehay (1979), p. 182 (No. 251).

49 E. Schiele, Ich ewiges Kind. Gedichte, Vienna/Munich () 1985, pp. 12f.

50 Nebehay (1979), p. 228 (No. 397).

51 Cf. P. Hatvani's comment (1917) on Schiele's expressionism in Fischer/Haefs (1988), p. 367.

52 Nebehay (1979), p. 221 (No. 351).

53 Ibid.

54 Roessler (1948), p. 62.

55 E. di Stefano, 'Die zweigesichtige Mutter' in W. Pircher (ed.), Début eines Jahrhunderts. Essays zur Wiener Moderne, Vienna 1985, p. 118.

56 Nebehay (1979), p. 252 (No.483).

57 Ibid., p. 263 (No. 537).

58 Ibid., p. 266 (No. 551).

59 Ibid., p. 336 (No. 754).

60 Ibid., p. 152 (Note 4).

61 Ibid., p. 367 (No. 888).

62 Ibid., p. 372 (No. 919).

63 Ibid., p. 164 (No. 171).

64 Ibid., p. 314 (No. 774).

65 Werkner (1986), pp. 148ff.

66 Schiele (1985), p. 40.

67 Nebehay (1979), p. 270 (No. 573).

68 G. Trakl, Das dichterische Werk, Munich (11) 1987, p. 195.

69 Here as well it is not possible to present reproductions of the most important examples because Viennese collector Dr. Rudolf Leopold declined to make them available.

70 H. Deuchert, 'Jugendstil und Symbolismus' in H. Gercke (ed.), Der Baum (exhibition catalogue), Heidelberg 1985, p. 230.

71 Schiele (1985), p. 24.

72 Nebehay (1979), pp. 141f. (No. 155).

73 R. Muther, 'Brügge' in Aufsätze über bildende Kunst, vol. 3: Bücher und Reisen, Berlin 1914, p. 145. Also see the essay 'Das schwarze Venedig', Ibid., pp. 135ff.

74 Schiele (1985), p. 22.

75 K. A. Schröder, 'Der Welt nicht blind. Passagen zu Gustav Klimt und Egon Schiele' in K. A. Schröder/H. Szeemann (eds), Egon Schiele und seine Zeit, Munich 1988, p. 27.

76 Quoted from Fischer/Haefs (1988), p. 397.

77 Nebehay (1980), p. 178.

78 Nebehay (1979), pp. 417f. (No. 1182).

Picture credits

The publishers wish to thank the museums, collectors and archives who gave permission for the use of picture material. Particular thanks are due to Jane Kallir, New York, for her help. In addition to the institutions named in captions we wish to thank: The Galerie St. Etienne, New York, pp. 8, 10, 12, 23, 24, 27, 32, 33, 34, 44, 49, 56, 59, 63, 70, 80, 86, 91 (by kind permission of the gallery); Graphische Sammlung Albertina, Vienna pp. 7, 18, 94, 95; Fotostudio Otto, Vienna, pp. 66/67, 71, 76, 77, 82/83, 87; Bildarchiv Alexander Koch, Munich, pp. 13, 69, 72; The Bridgeman Art Library, London, pp. 14, 75; Photo: Statens Konstmuseer, Stockholm, p. 1; Scala, Florence, p. 22; Artothek, Peissenberg, p. 73; © Foto Fürböck, Graz, p. 31; Historisches Museum der Stadt Wien, p. 95 bottom left; © Sotheby's, p. 37; the publisher's archives, pp. 26, 28, 38/39, 46, 50, 88/89